DAVID BUSCH'S COMPACT FIELD GUIDE FOR THE

SONY® α
SLT-A55/A35/A33

David D. Busch

Course Technology PTR
A part of Cengage Learning

COURSE TECHNOLOGY
CENGAGE Learning·

Australia, Brazil, Japan, Korea, Mexico, Singapore, Spain, United Kingdom, United States

COURSE TECHNOLOGY
CENGAGE Learning·

David Busch's Compact Field Guide for the Sony® α SLT-A55/A35/A33

Publisher and General Manager, Course Technology PTR:
Stacy L. Hiquet

Associate Director of Marketing:
Sarah Panella

Manager of Editorial Services:
Heather Talbot

Marketing Manager:
Mark Hughes

Executive Editor:
Kevin Harreld

Project Editor:
Jenny Davidson

Series Technical Editor:
Michael D. Sullivan

Interior Layout Tech:
Bill Hartman

Cover Designer:
Mike Tanamachi

Indexer:
Katherine Stimson

Proofreader:
Sara Gullion

For product information and technology assistance, contact us at **Cengage Learning Customer & Sales Support, 1-800-354-9706.**

For permission to use material from this text or product, submit all requests online at **cengage.com/permissions**. Further permissions questions can be e-mailed to **permissionrequest@cengage.com**.

Sony is a registered trademark of Sony Corporation in the United States and other countries.

All other trademarks are the property of their respective owners.

All images © David D. Busch unless otherwise noted.

Library of Congress Control Number: 2011940301

ISBN-13: 978-1-133-73242-6

ISBN-10: 1-133-73242-9

Cengage Learning is a leading provider of customized learning solutions with office locations around the globe, including Singapore, the United Kingdom, Australia, Mexico, Brazil, and Japan. Locate your local office at: **international.cengage. com/region**.

Cengage Learning products are represented in Canada by Nelson Education, Ltd.

For your lifelong learning solutions, visit **courseptr.com**.

Visit our corporate Web site at **cengage.com**.

Printed in the United States of America
1 2 3 4 5 6 7 12 11

Contents

Introduction

Throw away your cheat-sheets and command cards! Are you tired of squinting at tiny color-coded tables on fold-out camera cards? Do you wish you had the most essential information extracted from my comprehensive *David Busch's Sony Alpha SLT-A55/A33 Guide to Digital Photography* or *David Busch's Sony Alpha SLT-A35 Guide to Digital Photography* in a size you could tuck away in your camera bag? I've condensed the basic reference material you need for all three cameras in this handy, lay-flat book, *David Busch's Compact Field Guide for the Sony Alpha SLT-A55/A35/A33*. In it, you'll find the explanations of *why* to use each setting and option—information that is missing from the cheat-sheets and the manual packaged with the camera. You *won't* find the generic information that pads out the other compact guides. I think you'll want to have both this reference and one of my full-sized guides—one to help you set up and use your Alpha SLT-A55, A35, or A33, and the other to savor as you master the full range of things this great camera can do.

About the Author

With more than a million books in print, **David D. Busch** is the world's #1 selling digital camera guide author, and the originator of popular digital photography series like *David Busch's Pro Secrets, David Busch's Quick Snap Guides,* and *David Busch's Guides to Digital SLR Photography*. As a roving photojournalist for more than 20 years, he illustrated his books, magazine articles, and newspaper reports with award-winning images. Busch operated his own commercial studio, suffocated in formal dress while shooting weddings-for-hire, and shot sports for a daily newspaper and upstate New York college. His photos and articles have appeared in *Popular Photography & Imaging, Rangefinder, The Professional Photographer*, and hundreds of other publications. He's also reviewed dozens of digital cameras for CNet and *Computer Shopper*, and his advice has been featured on NPR's *All Tech Considered*. Visit his website at www.dslrguides.com/blog.

Back cover author photo by Nancy Balluck, http://www.nancyballuckphotography.com/

Chapter 1

Quick Setup Guide

This chapter contains the essential information you need to get your Sony Alpha SLT-A55/A35/A33 prepped and ready to go. You'll learn how to use a few of the basic controls and features, and how to transfer your photos to your computer. If you want a more complete map of the functions of your camera, skip ahead to Chapter 2.

Pre-Flight Checklist

The initial setup of your Alpha SLT is fast and easy. You just need to learn a few controls, charge the battery, attach a lens, and insert a Secure Digital or Memory Stick Pro Duo card.

Charging the Battery

When the battery is inserted into the charger properly (it's impossible to insert it incorrectly), a Charge light begins glowing yellow-orange, without flashing. When the battery completes the charge, the lamp turns off, approximately 250 minutes later. When the battery is charged, remove it from the charger, flip the lever on the bottom of the camera, and slide the battery in. (See Figure 1.1.)

If the charging lamp flashes when you insert the battery, that flashing indicates an error condition. Make sure you have the correct model number battery and that the charger's contacts (the shiny metal prongs that connect to the battery) are clean. To remove the battery, you must press a blue lever in the battery compartment that prevents the pack from slipping out when the door is opened.

Introducing Menus and Navigation Controls

You'll find descriptions of most of the controls used with the SLT-A55/A35/A33 in Chapter 2, which provides a complete "roadmap" of the camera's buttons and dials and switches. However, you may need to perform a few tasks

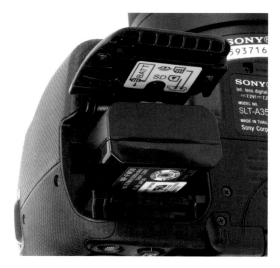

Figure 1.1
Insert the battery in the camera; it only fits one way.

during this initial setup process, and most of them will require the MENU button, mode dial, control dial, and the controller pad.

- **MENU button.** It's located to the upper-left corner of the top panel of the camera, as seen at left in Figure 1.2. (The MENU label beneath the button on the A35, and to the left of it on the A55/A33.) When you want to access a menu, press it. To exit most menus, press it again.

- **Mode dial.** This dial changes among exposure and Scene modes, as you can see at left in Figure 1.2. The dial's labels are slightly different between the A55/A33 and A35 (the A35 version is shown), but their functions are the same.

- **Control dial.** On the hand grip in front of the shutter release on top of the camera, used to navigate between top-level menus and to change camera settings. (Not shown in the figure.)

- **Directional/controller pad.** A thumbpad-sized button with indentations at the North, South, East, and West "navigational" positions, plus a button in the center marked "AF" (see Figure 1.2, right). With the Alpha, this pad is used extensively to navigate among menus on the LCD or to choose one of the focus points, to advance or reverse display of a series of images during picture review. The center controller button is used to confirm your choices. Each of the button positions does double duty to directly access some other function of the Alpha camera, such as ISO or white balance settings, as I'll explain in Chapter 2. That chapter also will tell you how to use the Fn/Rotate button (at top in the figure), as well as the Playback and Trash buttons (at bottom in the figure).

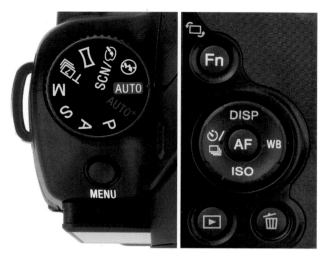

Figure 1.2
The controller has four directional buttons for navigating up/down/left/right, and a center controller button to confirm your selection.

Mounting the Lens

If your Alpha has no lens attached, you'll need to mount one before shooting:

1. Select the lens and loosen (but do not remove) the rear lens cap.

2. Remove the body cap on the camera by rotating the cap towards the release button.

3. Once the body cap has been removed, remove the rear lens cap from the lens, set it aside, and then mount the lens on the camera by matching the alignment indicator on the lens barrel with the red dot on the camera's lens mount. (See Figure 1.3.) Rotate the lens away from the shutter release until it seats securely.

4. Set the focus mode switch on the lens to AF (autofocus). If the lens hood is bayoneted on the lens in the reversed position (which makes the lens/hood combination more compact for transport), twist it off and remount with the "petals" facing outward. A lens hood protects the front of the lens from accidental bumps, and reduces flare caused by extraneous light arriving at the front element of the lens from outside the picture area.

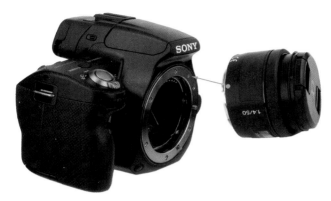

Figure 1.3
Match the indicator on the lens with the red dot on the camera mount to properly align the lens with the bayonet mount.

Adjusting Diopter Correction

Those of us with less than perfect eyesight can often benefit from a little optical correction in the viewfinder. Your contact lenses or glasses may provide all the correction you need, but if you are a glasses wearer and want to use the Sony Alpha without your glasses, you can take advantage of the camera's built-in diopter adjustment correction to match that of your glasses or your eyesight with your glasses on. Turn on the camera, look into the electronic viewfinder, focus your eye on the numbers and other indicators on the viewfinder's screen, then rotate the diopter adjustment wheel (see Figure 1.4) while looking into the viewfinder until the numbers and indicators appear sharp.

Figure 1.4
Viewfinder diopter correction can be dialed in.

Diopter adjustment wheel

Inserting and Using a Secure Digital Card or Memory Stick Pro Duo

The Alpha accepts both Secure Digital (or Secure Digital High Capacity) and Sony Memory Stick Pro Duo (or Memory Stick Pro-HG Duo) cards. It doesn't matter which type you use, but you can only use one or the other; there is only one memory card slot in the camera.

Whether you ultimately opt for a Memory Stick PRO Duo or a variety of SD card, either type of card fits in the same slot underneath the door on the right side of the bottom of the camera. You should only remove the memory card when the camera is switched off. Insert the memory card with the label facing the back of the camera (for a Secure Digital card), or towards the front of the camera if inserting a Memory Stick. In either case, the card should be oriented so the edge with the metal contacts goes into the slot first. (See Figure 1.5.) When you want to remove the memory card later, just press down on the card edge that protrudes from the slot, and it will pop right out.

I recommend formatting the memory card before each shooting session, to ensure that the card has a fresh file system, and doesn't have stray files left over. Format *only* when you've transferred all the images to your computer, of course. To format a memory card, press the MENU button, use the left/right buttons of the controller pad to choose the Memory Card Tool menu (which is represented by the memory card icon). The Format entry, which is the top line of this menu, should already be highlighted. Press the center controller button, and select Enter from the screen that appears. Press the center controller button once more to begin the format process.

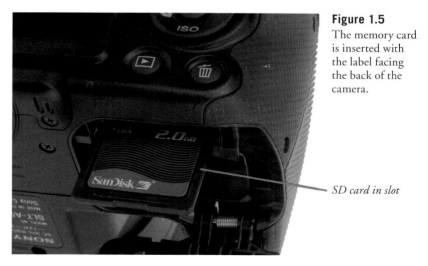

Figure 1.5
The memory card is inserted with the label facing the back of the camera.

SD card in slot

Selecting a Shooting Mode

You can choose a shooting method from the mode dial located on the top left of the Sony Alpha SLT (see Figure 1.6). The dials differ slightly between the A55/A33 and A35, but, except for the extra image processing modes available with the A35, their functions are identical. There are six special shooting modes (including two Auto modes), in some of which the camera makes many or most of the decisions for you (apart from when to press the shutter), and four semi-automatic and manual modes, which allow you to provide the maximum input over the exposure and settings the camera uses.

Turn your camera on by flipping the power switch to ON. Next, you need to select which shooting mode to use. If you're very new to digital photography, you might want to set the camera to an automatic mode (either the Auto or the Auto+ setting on the mode dial) or the P (Program mode) setting and start snapping away. If you have a specific type of picture you want to shoot, you can turn the mode dial to the SCN setting, press the Fn button, and then press the center controller button on the controller pad (it's labeled AF), and try out

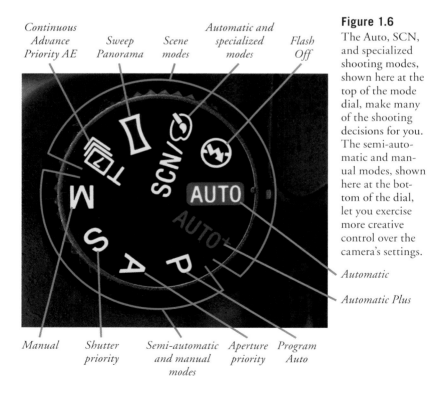

Continuous Advance Priority AE Sweep Panorama Scene modes Automatic and specialized modes Flash Off

Manual Shutter priority Semi-automatic and manual modes Aperture priority Program Auto

Automatic

Automatic Plus

Figure 1.6
The Auto, SCN, and specialized shooting modes, shown here at the top of the mode dial, make many of the shooting decisions for you. The semi-automatic and manual modes, shown here at the bottom of the dial, let you exercise more creative control over the camera's settings.

one of the scene types by scrolling down the list of options using the control dial or directional buttons to scroll down the list. Press the center controller button to highlight and select your choice.

When you first switch to a shooting mode, a help screen like the ones shown in Figure 1.7 appear on the LCD display to provide a "briefing" about that mode. The help screen disappears when you press any controller pad button or touch the shutter release and is replaced by one of the standard viewing screens. (You can dispense with these help screens through the Setup 1 menu, as discussed in Chapter 3.) The available modes are:

- **Auto+.** In this mode, the Alpha makes all the exposure decisions for you, and will pop up the flash if necessary under low-light conditions. In addition, it will use its programming to select certain additional functions as indicated by the shooting conditions. In particular, in certain situations the camera will take multiple shots and then combine them internally in order to achieve an improved final image. Using these techniques, the camera attempts to recognize certain Scene types: Night View, Hand-held Twilight, Landscape, Backlight Portrait, Portrait, Tripod Night View, Backlight, Macro, and Night Portrait.

- **Auto.** In this mode, the Alpha makes all the exposure decisions for you, and will pop up the flash if necessary under low-light conditions.

- **Flash Off.** This is the mode to use in museums and other locations where the use of flash is forbidden or inappropriate. It otherwise operates exactly like the Auto setting but disables the pop-up internal flash.

- **SCN/Picture Effect (A35 only).** When you turn the mode dial to this setting, the left side of the LCD (or viewfinder) presents you with a menu of Scene types to select from. Scroll through this list using the control dial or the controller pad buttons to choose from among the eight options listed below. If the camera is already set to SCN mode, press the Fn

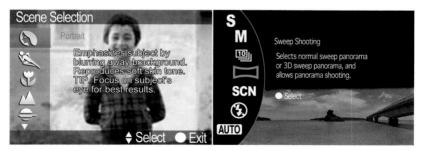

Figure 1.7 Help screens appear briefly when you select a Scene or Picture Effect mode (left), or any other shooting mode (right).

button on the back of the camera to activate the Function menu, then highlight the scene selection icon at the upper left of the screen, press the center controller button, and scroll through the choices to select a different scene type. In addition to the Scene modes listed next, with the A35 this SCN setting also provides access to 11 Picture Effects (not available in the A55 or A33).

■ **Portrait.** Use this mode when you're taking a portrait of a subject positioned relatively close to the camera and want to de-emphasize the background, maximize sharpness of the subject, and produce flattering skin tones.

■ **Sports Action.** Use this mode to freeze fast-moving subjects. The camera uses a fast shutter speed and shoots continuously while you hold down the shutter button, to capture the action as it unfolds.

■ **Macro.** This mode is helpful when you are shooting close-up pictures of a subject from about one foot away or less.

■ **Landscape.** Select this mode when you want extra sharpness and rich colors of distant scenes.

■ **Sunset.** This is a great mode to accentuate the reddish hues of a sunrise or sunset.

■ **Night View.** This mode is suited for night time scenes at a distance, such as city skylines. The camera will use a slow shutter speed and will not fire the flash, so it is a good idea to use a tripod to avoid blur from camera movement during the exposure.

■ **Hand-held Twilight.** Use this mode for night scenes when it's not practical to use a tripod. The camera sets itself to use a higher ISO (light sensitivity) setting so that it can use a faster shutter speed. It takes a continuous burst of several images, then processes them together internally into a single image that removes the visual "noise" that can result from high ISO settings.

■ **Night Portrait.** Choose this mode when you want to illuminate a subject in the foreground with flash, but still allow the background to be exposed properly by the available light. Be prepared to use a tripod or to rely on the SteadyShot feature to reduce the effects of camera shake. If there is no foreground subject that needs to be illuminated, you may do better by using the Night View mode.

■ **Sweep Shooting.** When you turn the dial to this next setting, marked by the icon of a stretched rectangle, the camera presents a brief menu at the left side of the screen or viewfinder with two options for shooting in-camera panoramas. The two choices are discussed below.

■ **Sweep Panorama.** This special mode lets you "sweep" the camera across a scene that is too wide for a single image. The camera takes multiple pictures and combines them in the camera into a single, wide panoramic final product.

■ **3D Sweep Panorama.** With this setting, which is a subset of the Sweep Panorama mode, the camera takes a sweeping panorama that can be displayed in 3D on a compatible 3D Sony (naturally) HDTV. You can also convert the camera's 3D images to a format that can be printed out or viewed on a computer screen or non-3D TV using ordinary red/blue 3D glasses.

■ **Tele-zoom Continuous Advance Priority AE.** This shooting mode, the last of the automatic or specialized modes, is marked on the mode dial by a stack of rectangles containing a number 7, indicating the maximum number of continuous shots per second that the camera will take in this mode.

If you have more photographic experience, you might want to opt for one of the semi-automatic or manual modes. They let you apply a little more creativity to your camera's settings. These modes are indicated on the mode dial by the letters P, A, S, and M:

■ **P (Program auto).** This mode allows the Alpha to select the basic exposure settings, but you can still override the camera's other choices to fine-tune your image.

■ **A (Aperture priority).** Choose this mode when you want to use a particular lens opening, especially to control sharpness, isolate a background using a wide lens opening, or to manage how much of your image is in focus. The Alpha will select the appropriate shutter speed for you.

■ **S (Shutter priority).** This mode is useful when you want to use a particular shutter speed to stop action or produce creative blur effects. The Alpha will select the appropriate f/stop for you.

■ **M (Manual).** Select this mode when you want full control over the shutter speed and lens opening, either for creative effects or because you are using a studio flash or other flash unit not compatible with the Alpha's automatic flash metering. In Manual mode, the camera will still display a suggested exposure.

Choosing a Metering Mode

You might want to select a particular metering mode for your first shots, although the default Multi segment metering (which is set automatically when you choose a Scene mode) is probably the best choice as you get to know your

camera. To change metering modes (you must not be using one of the Auto or SCN modes), press the Fn button (located on the back of the camera to the right of the LCD) and, using the controller pad's up/down and left/right buttons, navigate to the right side of the screen and select Metering mode from the Function menu by pressing the center controller button while that icon is highlighted. Then, use the up/down keys or turn the control dial, and select one of the three modes described below. Press the center controller button or press halfway down on the shutter button to confirm your choice. The three metering options available in PSAM modes are shown in Figure 1.8:

- **Multi segment metering.** The standard metering mode, and the only choice available in Auto or Scene modes; the Alpha attempts to intelligently classify your image and choose the best exposure based on readings from 1,200 different zones in the frame.

- **Center weighted metering.** The Alpha meters the entire scene, but gives the most emphasis to the central area of the frame.

- **Spot metering.** Exposure is calculated from a smaller central spot.

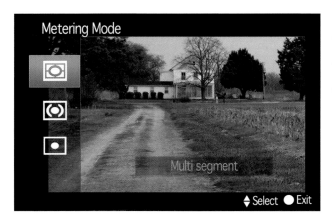

Figure 1.8
Metering modes (top to bottom) Multi segment, Center weighted, and Spot.

Choosing a Focus Mode

You can easily switch between automatic and manual focus by moving the AF/MF switch on the lens mounted on your camera. (If the lens doesn't have this switch, then you need to use the switch located on the front of the camera next to the lens mount.) However, if you set this switch to AF, you'll still need to choose an appropriate focus mode on the camera, as discussed below. If you're using a Scene, Auto, or Panorama shooting mode, the focus method is set for you automatically, and the AF mode selection will be grayed out and unavailable for selection.

To set the camera's autofocus mode, press the Fn button and navigate with the controller buttons to Autofocus mode on the left side of the Function menu. Then select the mode you want from the screen that pops up (see Figure 1.9) using the up/down controller keys or the control dial. Press the center controller button to confirm your selection. The three choices are as follows:

- **Single-shot (AF-S).** This mode, sometimes called *single autofocus*, locks in a focus point when the shutter button is pressed down halfway, and the green focus confirmation circle glows in the viewfinder or on the LCD. The focus will remain locked until you release the shutter button or take the picture. If the camera is unable to achieve sharp focus, the focus confirmation light will blink. This mode is best when your subject is relatively motionless.

- **Automatic AF (AF-A).** In this mode, the Alpha switches between Single-shot and Continuous AF as appropriate. That is, it locks in a focus point when you partially depress the shutter button (Single-shot mode), but switches automatically to Continuous AF if the subject begins to move. This mode is handy when photographing a subject, such as a child at quiet play, who might move unexpectedly.

- **Continuous AF (AF-C).** This mode, sometimes called *continuous servo*, sets focus when you partially depress the shutter button, but continues to monitor the frame and refocuses if the camera or subject is moved. This is a useful mode for photographing sports and moving subjects.

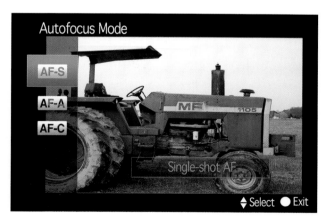

Figure 1.9
Set Autofocus mode from the Function menu. The choices from top to bottom are Single-shot AF, Automatic AF, and Continuous AF.

Selecting a Focus Point

The Sony Alpha SLT uses 15 different focus points to calculate correct focus. In the Auto and SCN modes, as well as the Sweep Panorama mode, or when the Smile Shutter is activated, the focus point is selected automatically by the camera. In the semi-automatic and manual modes, you can allow the camera to select the focus point automatically, or you can specify which focus point should be used.

You make your decision about how the focus point is chosen by setting the AF area through the Function menu. There are three AF area options, shown in Figure 1.10. Press the Fn button, navigate to the AF area selection on the left side of the screen, press the center controller button, and select one of these three choices. Press the center controller button again to confirm.

- **Wide.** The Alpha chooses the appropriate focus zone from the 15 AF areas on the screen.
- **Spot.** The Alpha always uses the center, cross-type focus zone to calculate correct focus.
- **Local.** Use the controller's direction buttons or the control dial to move the focus zone to any single position among the 15 focus zones, and press the center controller button or press the shutter button halfway to exit to the shooting screen. If you want to return to the screen to move the focus point, press the center controller/AF button to bring the selection screen back, and move the focus point as before.

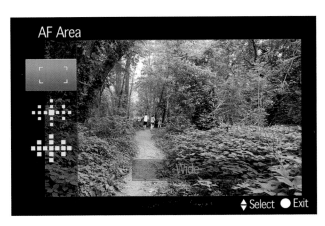

Figure 1.10
Select from Wide (the Alpha selects one of the 15 AF areas), Spot (only the center focus spot is used), or Local (you can choose which area to use).

Adjusting White Balance and ISO

If you like, you can custom-tailor your white balance (color balance) and ISO sensitivity settings, as long as you're not using one of the Auto or SCN shooting modes. In the Sweep Panorama modes, you can adjust white balance but not ISO. To start out, it's best to set white balance (WB) to Auto, and ISO to ISO 200 for daylight photos, and to ISO 400 for pictures in dimmer light. White balance and ISO both have direct-setting buttons located on the controller pad. Or, if you prefer, you can get access to both settings by pressing the Fn button and navigating to these settings on the Function menu.

Using the Self-Timer

If you want to set a short delay before your picture is taken, you can use the self-timer. Press the drive button (which doubles as the left controller button on the back of the camera), and use the up/down controller buttons or the control dial to highlight the self-timer icon, then press the left/right controller buttons to select from either the 10-second or 2-second self-timer. Press the center controller button to confirm your choice (see Figure 1.11) and a self-timer icon will appear on the recording information display on the back of the Sony Alpha. (It won't appear in the viewfinder.) Press the shutter release to lock focus and exposure and start the timer. The red self-timer lamp in the hand grip will flash and the beeper will count down (unless you've silenced it in the menus) until the final two seconds (in 10-second mode), when the lamp stays lit and the beeper beeps more rapidly. In the 2-second mode, the lamp stays lit and the beeper sounds off rapidly for the entire time.

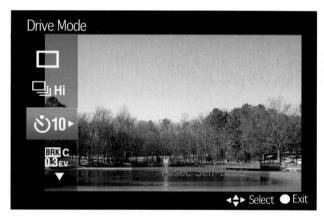

Figure 1.11
The Drive modes include (top to bottom) Single-shot, Continuous, Self-timer, and Exposure Bracketing. The White Balance Bracketing and Remote Commander options are not shown.

In addition to the Self-timer, Continuous shooting, and Single-shot choices in the Drive menu, there are also bracketing and infrared remote control options (not shown in the figure).

Reviewing the Images You've Taken

The Sony Alpha has a broad range of playback and image review options. Here is all you really need to know at this time, as shown in Figure 1.12.

■ Press the Playback button (the bottom button immediately to the lower right of the LCD, marked with a hard-to-see dark blue right-pointing triangle) to display the most recent image on the LCD.

■ Press the left controller button, or scroll the control dial on the front of the camera to the left, to view a previous image.

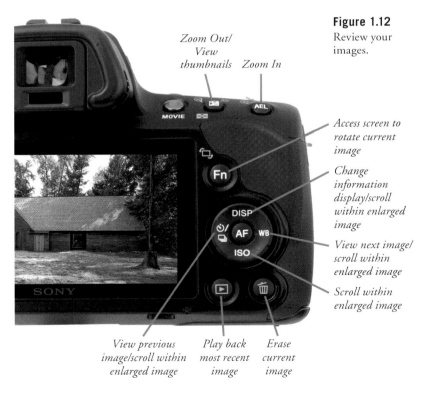

Figure 1.12
Review your images.

Zoom Out/ View thumbnails Zoom In

Access screen to rotate current image

Change information display/scroll within enlarged image

View next image/ scroll within enlarged image

Scroll within enlarged image

View previous image/scroll within enlarged image Play back most recent image Erase current image

- Press the right controller button, or scroll the control dial to the right, to view the next image.

- Press the Trash button to delete the currently displayed image.

- Press the Fn button, followed by the center controller button, to rotate the image 90 degrees. Successive presses of the center button rotate it 90 degrees each time. (You won't likely need this feature unless you have disabled automatic rotation, which causes the camera to display your vertically oriented pictures already rotated. I'll explain how to activate/deactivate automatic rotation in Chapter 3.)

- Press the Zoom In/AEL and Zoom Out/Index buttons at the top of the camera's back to select zoomed and full-screen views. Press either button repeatedly to change the zoom level. You can press the Playback button to resume normal viewing quickly.

- Rotate the control dial located on the front of the camera to display a different image at the same zoom level.

- Use the left/right/up/down controller keys to scroll around within a magnified image. An inset box shows the relationship of the magnified image to the entire frame.

- Press the DISP button repeatedly to cycle among views that have no recording data, full recording data (f/stop, shutter speed, image quality/size, etc.), and a thumbnail image with histogram display.

- Press the Zoom Out/Index button to display an index screen showing 6 or 12 thumbnail images. (You can select 6 or 12 images using the Playback menu, as I'll discuss in Chapter 3.) Press the AV button again to return to the single-image display.

Using the Built-in Flash

Working with the SLT-series' built-in flash unit deserves a chapter of its own, and I'm providing one. (See Chapter 4.) But the SLT's flash is easy enough to work with that you can begin using it right away, either to provide the main lighting of a scene, or as supplementary illumination to fill in the shadows.

Your options for using the flash depend on what shooting mode the camera is set to. For example, in the two Auto modes, the SCN modes, and the Sweep Panorama modes, the camera decides whether or not to pop up the flash, and you cannot pop it up even if you press the round Flash button on the side of the camera below the flash unit. If the camera's programming determines that flash is needed, it will pop up the unit. Once it is popped up though, you will

have some options for controlling it, by pressing the Fn key and selecting Flash Control from the Function menu. You can choose to leave the flash on its initial setting of Autoflash, to force it off, or to force it on, for fill flash. (In the Flash Off shooting mode, not surprisingly, the camera will not pop up the flash unit and neither can you.)

In the other shooting modes—P, A, S, M, and Continuous Advance Priority AE—you have more control over the built-in flash. The camera will not use it unless you manually pop it up by pressing the Flash button. Once it is popped up, you can use the Flash Control item on the Function menu to select from various flash options: Forced on (Fill-flash), Slow Sync, and Rear Sync. In those shooting modes, you don't have the Forced Off or Auto-flash options available. You also have one other setting available—Wireless, which enables you to fire a remote flash unit using the SLT's flash as the controller.

Movie Making in a Nutshell

I'm going to talk in more detail about your movie-making options with the SLT-A35 in Chapter 5. The SLT cameras have advanced motion-picture capabilities, including the ability to produce excellent quality high definition (HD) movies. You can adjust several shooting settings, including exposure compensation, white balance, AF area, and others. The SLT cameras also provide a breakthrough ability in that they can continuously autofocus on your scene using Phase Detection focusing with Live View.

For now, just press the MENU button at the left of the camera's top, make sure the number 1 menu list at the far left is highlighted, and, using the control dial or the down controller button, scroll down to highlight the Movie: File Format line. Make sure the AVCHD option is selected. If it isn't, use the controller buttons and the center controller button to scroll to that option and highlight it, then exit from the menu by pressing the MENU button again.

With the camera turned on in any shooting mode, aim at your subject and locate the red Movie button just to the right of the viewfinder, angled toward the back of the camera. Press that button once to start the recording, and again to stop it; don't hold down the button. You can record for up to about 29 minutes consecutively if you have sufficient storage space on your memory card and charge in your battery, if you have the SteadyShot image stabilizing system turned off. If SteadyShot is turned on, the continuous-shooting limit is about 9 minutes.

The camera will adjust the focus and exposure automatically, and you can zoom while recording, if you have a zoom lens attached to the camera. When the movie has been recorded, you can press the Play button on the back of the

camera to view it immediately. While a movie is playing, the buttons on the controller act like VCR buttons, as follows:

■ **Pause/Resume.** Press the center controller button.

■ **Fast-forward.** Press the right direction button while the movie is playing.

■ **Fast-reverse.** Press the left direction button while the movie is playing.

■ **Slow-forward.** Turn the control dial to the right while the movie is paused.

■ **Fast-reverse.** Press the control dial to the left while the movie is paused.

■ **Adjust sound volume.** Press the bottom direction button to bring up the volume control on the screen, then raise or lower the volume by using the top and bottom buttons or by turning the control dial.

■ **Turn recording information on or off.** Press the DISP button (up controller button).

Transferring Photos to Your Computer

The final step in your picture-taking session will be to transfer the photos you've taken to your computer for printing, further review, or image editing. Transfer your images by either using a cable transfer from the camera to the computer or removing the memory card from the Alpha and transferring the images with a card reader, which is usually the best, because it's usually much faster and doesn't deplete the battery of your camera.

To transfer images from a memory card to the computer using a card reader:

1. Turn off the camera.

2. Slide open the memory card door, and press on the card, which causes it to pop up so it can be removed from the slot.

3. Insert the memory card into a memory card reader that is plugged into your computer. Your installed software detects the files on the card and offers to transfer them. The card can also appear as a mass storage device on your desktop, which you can open and then drag and drop the files to your computer.

To transfer images from the camera to a Mac or PC computer using the USB cable:

1. Turn off the camera.

2. Open the port door on the left side of the camera and plug the USB cable furnished with the camera into the USB port, the lower of the two openings inside that door. (See Figure 1.13.)

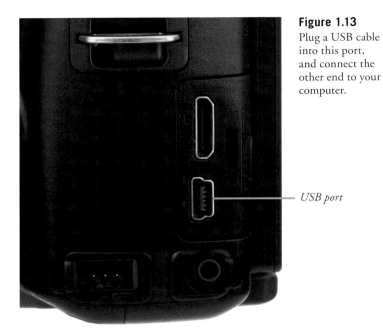

Figure 1.13
Plug a USB cable into this port, and connect the other end to your computer.

USB port

3. Connect the other end of the USB cable to a USB port on your computer.

4. Turn on the camera. Your installed software usually detects the camera and offers to transfer the pictures, or the camera appears on your desktop as a mass storage device, enabling you to drag and drop the files to your computer.

Chapter 2

Sony Alpha Roadmap

You should find this roadmap of the functions of the Sony Alpha SLT's controls more useful than the tiny black-and-white drawings in the manual packed with the camera, which has dozens of cross-references that send you on an information scavenger hunt through dozens of pages. Everything you need to know about the controls themselves is here. You'll find descriptions of menus and settings in Chapters 3 and 4.

Sony Alpha: Front View

Figure 2.1 shows a pair of front views of the Sony Alpha. The main components you need to know about are as follows:

- **Shutter release button.** Angled on top of the hand grip is the shutter release button. Press this button down halfway to lock exposure and focus (in Single-shot mode and Continuous autofocus mode with non-moving subjects). The Alpha assumes that when you tap or depress the shutter release, you are ready to take a picture, so the release can be tapped to activate the exposure meter or to exit from most menus.

- **Control dial.** This dial is used to change shooting settings. When settings are available in pairs (such as shutter speed/aperture), this dial will be used to make one type of setting, such as shutter speed. The other setting, the aperture, is made using an alternate control, such as spinning the control dial while holding down the exposure compensation button (which resides conveniently under the thumb near the viewfinder window on the back of the camera). This dial also advances through your images in Playback mode.

- **Self-timer lamp.** This LED flashes red while your camera counts down the 10-second self-timer, flashing steadily at first, then switching to a constant glow in the final moments of the countdown. With the 2-second self-timer, the lamp stays lit during the entire countdown.

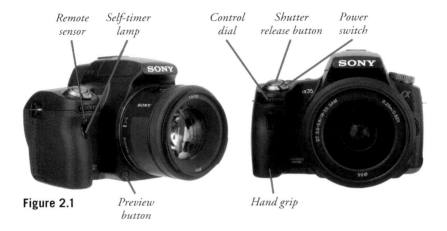

| Remote sensor | Self-timer lamp | | Control dial | Shutter release button | Power switch |

Figure 2.1 *Preview button* *Hand grip*

- **Remote sensor.** This small window in the hand grip, just above the self-timer lamp, is where you aim an infrared remote control, such as Sony's RMT-DSLR1 Remote Commander, an optional accessory. The remote control can trigger the camera's shutter, so you can avoid camera shake during delicate exposures.

- **Hand grip.** This provides a comfortable hand-hold, and also contains the Alpha's battery and memory card.

- **Preview button.** This control, sometimes known as a "depth-of-field preview button," lets you see how your image will look with the aperture stopped down to its actual value, before you press the shutter button. Normally, when you are viewing the image on the LCD or in the viewfinder in Recording mode, the lens is at its widest aperture, such as f/3.5, for example. Because the depth–of-field changes as the aperture gets smaller (with a larger number, such as f/8), viewing through the wide-open lens does not let you judge how much of the image will be in focus when the picture is actually recorded. When you press the Preview button, the lens stops down to the actual shooting aperture so you can judge what areas of the image will be in sharp focus at that aperture.

Figure 2.2 shows a front view of the SLT-A55/A35/A33 from the other side, with the electronic flash elevated. The controls here include:

- **Flash button.** This button releases the built-in flash so it can flip up and start the charging process. If you decide you do not want to use the flash, you can turn it off by pressing the flash head back down. Note that in some auto modes it will keep popping back up.

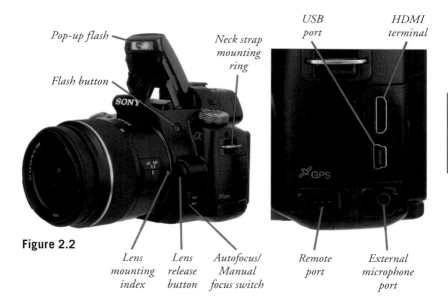

Figure 2.2

- **Lens release button.** Press and hold this button to unlock the lens so you can rotate the lens to remove it from the camera.
- **Lens switches.** Sony autofocus lenses have a switch to allow changing between automatic focus and manual focus, and, in the case of IS lenses, another switch to turn image stabilization on and off.
- **Port covers.** Flip back these covers to reveal four input/output/control ports described next:
- **Microphone input.** Plug a stereo microphone into this jack.
- **Remote control terminal.** You can plug various Sony remote release switches, timers, and wireless controllers into this connector. Note that the GPS icon appears above the remote control port only on the SLT-A55V, which has built-in GPS capabilities. It is not included on the A35/A33, or on A55 models built for sale outside the US in countries that restrict GPS usage.

- **USB/Video out port.** Plug in the USB cable furnished with your SLT-A55/A35/A33 and connect the other end to a USB port in your computer to transfer photos. Or, connect the AV cable and connect your camera to a television to view your photos on a large screen.
- **HDMI port.** Use a Type C HDMI cable (not included in the box with your camera) to direct the video and audio output of the Alpha to a high-definition television (HDTV) or HD monitor.

The SLT-A55/A35/A33's Back Panel

Most of the controls on the back panel of the Alpha are clustered on the right side of the body, with the exception of the MENU button perched on the back slope, just northwest of the LCD, and a few other items of note. The rear view of the camera is almost identical with the A55/A35/A33. Although the label is in a different location, the button is in the same position on the A35 (not pictured), which also lacks the swiveling LCD shown in Figure 2.3. Key components labeled in the figure include:

- **MENU button.** Summons/exits the menu displayed on the rear LCD of the Alpha. When you're working with submenus, this button also serves to exit a submenu and return to the main menu.
- **Viewfinder eyepiece.** You can frame your composition by peering into the viewfinder. It's surrounded by a removable soft rubber frame that seals out extraneous light when pressing your eye tightly up to the viewfinder, and it also protects your eyeglass lenses (if worn) from scratching.
- **Eye-Start sensors.** These sensors detect when your face or some other object approaches the viewfinder, and activates automatic focusing while turning off the LCD display. Some find this feature annoying, because it can be triggered by other objects (such as your body when carrying the camera, switched on, over your shoulder or around your neck). In Chapter 3, I'll show you how to disable this function. You might also want to turn it off when using the optional FDA-M1AM magnifying eyepiece or FDA-A1AM right-angle finder, because these accessories could activate the sensors.
- **Diopter correction wheel.** Rotate this to adjust eyesight correction applied when looking through the Alpha's viewfinder.
- **LCD.** This is the 3-inch display that shows your Live View preview; image review after the picture is taken; recording information display before the photo is snapped; and all the menus used by the Sony Alpha. With the A55 and A33, this LCD swivels to allow different viewing angles.

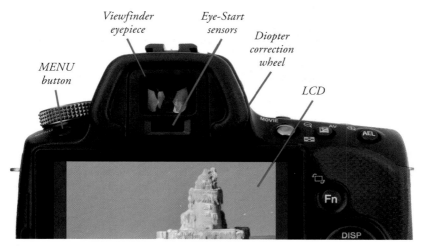

Figure 2.3

The control cluster on the right side of the back of the camera includes these buttons, shown in Figure 2.4:

■ **Zoom Out/Exposure compensation/Playback index button.** This button has several functions, which differ depending on the camera's active mode.

In Shooting mode, with the mode dial set to Program, Aperture priority, Shutter priority, Sweep Panorama, or Continuous Advance Priority AE, press this button to produce the exposure compensation display. Then, press the left/right controller keys or turn the control dial to add or subtract from the camera's exposure setting. In Manual exposure mode, press this button while spinning the control dial to change the aperture. (Release the button and spin the control dial to change the shutter speed.)

In Playback mode, press this button to display an index screen showing 6 or 12 of your images at a time (select 6 or 12 through the Playback menu), and press again to return to full screen view. When the image being played back is zoomed in, press this button to zoom it back out. Each press zooms the image out one more step, until it is back to normal size. If you press the button one more time after that, the index screen is displayed.

■ **AEL/Zoom In button.** In Shooting mode, pressing this button locks your exposure setting. With the exposure locked, you can first aim the camera at a subject whose brightness will yield your desired results. Once

Figure 2.4

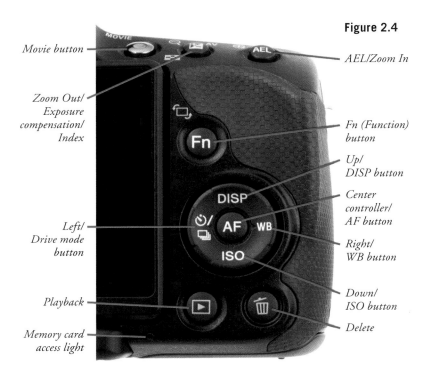

Movie button

AEL/Zoom In

Zoom Out/
Exposure
compensation/
Index

Fn (Function)
button

Up/
DISP button

Center
controller/
AF button

Left/
Drive mode
button

Right/
WB button

Down/
ISO button

Playback

Delete

Memory card
access light

you have made that exposure reading by pressing the shutter button half-way, press the AEL button, and that exposure reading will remain locked in. Now, aim the camera at your actual subject, and press the shutter button to refocus and take the picture, using the locked-in exposure setting.

The AEL button has one other function in Shooting mode. When you are using Manual exposure mode, press this button while turning the control dial to select another pair of shutter speed and aperture settings that is equivalent to the pair initially set.

You can change the behavior of the AEL button in Shooting mode using the Custom 1 menu, and choosing the AEL Hold item. If you set it to Hold, you have to hold the button down to keep the exposure locked; if you set it to Toggle, you can press and release it to lock exposure; then press it again to cancel that setting. Either way, whenever you have exposure locked with this button, an asterisk (*) appears in the viewfinder or on the LCD.

Finally, the AEL button is used in Playback mode to zoom in the image that is displayed on the LCD. Press the button repeatedly to zoom in to

greater levels of magnification. The maximum zoom factor is about 11.8 times for Large images. The maximum zoom levels are less for Medium and Small images. The Hold/Toggle menu settings have no effect on the playback zooming function of the AEL button.

■ **Movie button.** This red button is your gateway to movie-making with the A55/A35/A33 cameras. Its operation is about as simple as it gets—just press the button once to start recording a movie, and press it again to stop the recording. The more involved aspects of video recording are handled through the menu system. I'll discuss your movie-making options in Chapter 5.

■ **Fn (Function) button.** In Shooting mode, pressing this button pops up a screen on the LCD or in the viewfinder with options for selecting various settings, depending on what shooting mode the camera is set to. When you're shooting in one of the semi-automatic or manual modes (P, A, S, or M), settings available include Drive mode, Flash mode, Autofocus mode, AF area, Face Detection, Smile Shutter, ISO, Metering mode, Flash Exposure Compensation, White Balance (color bias), the Dynamic Range Optimizer (to improve highlight/shadow detail), and a Creative Style (such as Vivid, Portrait, or Sunset). (See Figure 2.5.)

In Playback mode, press the Fn button to pop up a screen that allows you to rotate the current image by 90 degrees each time you press the center controller button.

■ **Center controller/Enter/AF button.** The center controller button can be used as an Enter key to confirm menu choices when a menu is shown on the screen. In any autofocus mode, pressing this button causes the camera to autofocus on the subject, unless the AF area is set to Local. In that case, pressing this button brings up a screen to let you adjust the location of the focusing area.

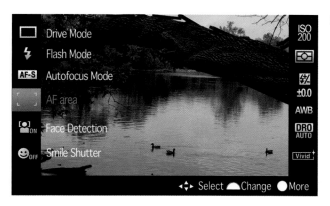

Figure 2.5

■ **Directional/Controller buttons.** Press the left/right/up/down keys to navigate menus and to move the viewing area around within magnified images and to navigate within displays of image thumbnails during playback. In addition, when the AF area is set to Local, you can use the directional keys to select any of the positions for the autofocus sensor. The left/right keys also move to the previous/next image on your memory card in Playback mode. In addition to their duties as navigational buttons, each of the four directional buttons has another identity, as set forth on its label. Those other functions are discussed next for each of the four buttons.

■ **Up/DISP button.** When in Shooting mode and using the LCD, press the DISP button repeatedly to cycle among the four recording information displays available while you are taking photos. They are the graphic display (Figure 2.6), the standard display (Figure 2.7), the basic information display (Figures 2.8), and the electronic level display (Figure 2.9, and not available with the A35). You can change the standard display to a screen that displays recording information only, without the Live View image, using the Display Rec. Data option on the Custom 2 menu. (Figure 2.10).

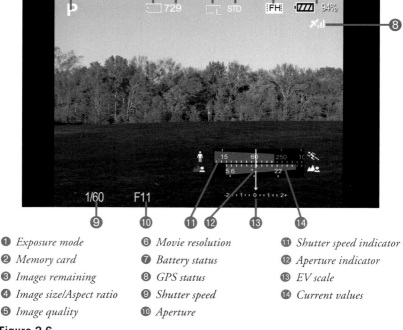

❶ Exposure mode	❻ Movie resolution	⓫ Shutter speed indicator
❷ Memory card	❼ Battery status	⓬ Aperture indicator
❸ Images remaining	❽ GPS status	⓭ EV scale
❹ Image size/Aspect ratio	❾ Shutter speed	⓮ Current values
❺ Image quality	❿ Aperture	

Figure 2.6

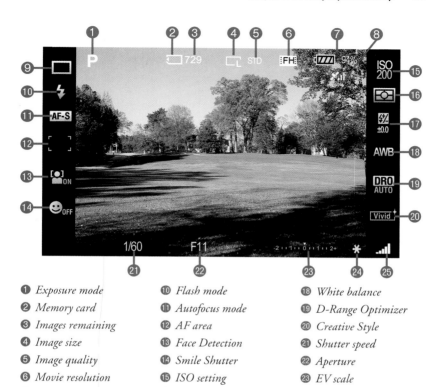

1. Exposure mode
2. Memory card
3. Images remaining
4. Image size
5. Image quality
6. Movie resolution
7. Battery status
8. GPS status
9. Drive mode
10. Flash mode
11. Autofocus mode
12. AF area
13. Face Detection
14. Smile Shutter
15. ISO setting
16. Metering mode
17. Flash exposure compensation
18. White balance
19. D-Range Optimizer
20. Creative Style
21. Shutter speed
22. Aperture
23. EV scale
24. AEL button status
25. SteadyShot scale

Figure 2.7

Figure 2.8

Figure 2.9

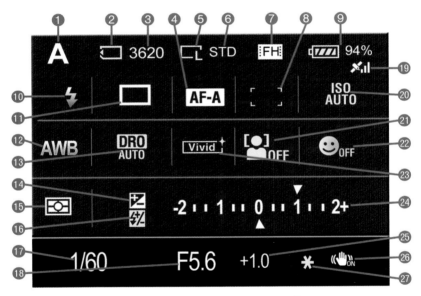

● Exposure mode
● Memory card
● Images remaining
● Autofocus mode
● Image size/aspect ratio
● Image quality
● Movie resolution
● Autofocus area
● Battery status

⑩ Flash mode
⑪ Drive mode
⑫ White balance
⑬ D-Range Optimizer
⑭ Exposure compensation
⑮ Metering mode
⑯ Flash exposure
 compensation
⑰ Shutter speed
⑱ Aperture

⑲ GPS status
⑳ ISO setting
㉑ Face Detection
㉒ Smile Shutter
㉓ Creative Style
㉔ EV scale
㉕ Exposure compensation
㉖ SteadyShot status
㉗ AEL button status

Figure 2.10

When using the viewfinder instead of the LCD, pressing the DISP button repeatedly will produce a slightly different sequence of just three different recording information displays: the graphic display, basic recording information, and the electronic level (not available on the A35). (For movies, there is no graphic display.)

In Playback mode, press the DISP button to cycle among the three available playback screens for showing your images: full recording data; histogram with recording data; and no recording data. (For movies, there are only two playback screens; there is no histogram screen.)

- **Right/WB button.** This button gives you immediate access to an important function that otherwise would require a trip to the Function menu using the Fn button. With this button, one push takes you straight to the screen for selecting among the various white balance options: Auto, Daylight, Shade, Cloudy, Incandescent, Fluorescent, Flash, Color Temperature, Color Filter, and Custom. You navigate through these choices with the up/down controller buttons or with the control dial. Use the left/right controller buttons to make further adjustments to any of the individual settings.

- **Down/ISO button.** This button gives you access to a menu for specifying ISO sensor sensitivity settings, from ISO 100 to ISO 12800 (and up to 25600 on the A35), plus Auto and Multi Frame Noise Reduction. Some of these settings may not be available, depending on the camera's other settings, including shooting mode and image quality. Scroll down through the list of these choices one line at a time using the up/down controller buttons or the control dial. If you prefer not to use this button, you can get to the same selection screen by using the Fn button and navigating through the Function menu.

- **Left/Drive mode button.** Press this button to produce a screen that lets you choose a drive mode. Then use the up/down buttons or the control dial to select from Single-shot advance; Continuous advance (with high- and low-speed options selectable with the left/right buttons); Self-timer (with 10- and 2-second options available with the left/right buttons); Continuous exposure bracketing (three shots with one shutter press, with exposure interval chosen using left/right buttons); White Balance bracketing (a series of three shots with a specified variation in white balance, selectable with left/right buttons); and Remote Commander shooting when using the optional RMT-DSLR1 Wireless Remote Commander.

■ **Trash button.** Press once if you want to delete the image displayed on the LCD. Then press the up/down controller buttons to choose Delete (to confirm your action) or Cancel (if you change your mind). Press the center controller button (Enter) to confirm your choice. This button also takes on the identity of the Focus Magnifier button if you turn on that function on the Custom 1 menu, so this button can be used to magnify the Live View image so you can judge the sharpness of the focus.

■ **Playback button.** Displays the last picture taken. Thereafter, you can move back and forth among the available images by pressing the left/right controller buttons or spinning the control dial to advance or reverse one image at a time. To quit playback, press this button again. The Alpha also exits Playback mode automatically when you press the shutter button (so you'll never be prevented from taking a picture on the spur of the moment because you happened to be viewing an image).

■ **Memory card access lamp.** When lit or blinking, this lamp indicates that the memory card is being read from or written to. Do not remove the battery, turn off the power, or remove the card while this lamp is lit, or your image data could be corrupted.

■ **Light sensor.** This "electric eye" found in the lower left corner of the LCD of the A55/A33 senses the amount of ambient illumination and can be set to adjust the brightness of the display automatically.

Going Topside

The top surface of the Sony Alpha SLT-A55/A35/A33 has several frequently accessed controls of its own. Only a few are located on the left side of the camera. They are labeled in Figure 2.11:

■ **Mode dial.** Rotate this dial to switch among Scene modes and semi-automatic and manual exposure modes. The dials differ slightly between the A55/A33 and A35.

■ **Accessory/Flash hot shoe.** Slide an electronic flash into this mount when you need a more powerful speedlight. A dedicated flash unit, like those from Sony, can use the multiple contact points shown to communicate exposure, zoom setting, white balance information, and other data between the flash and the camera. There's more on using electronic flash in Chapter 5. Unfortunately, Sony, like its Minolta predecessors (since 1988), uses a non-standard accessory/flash shoe mount, rather than the industry standard ISO 518 configuration. This keeps you from attaching electronic flash units, radio triggers, and other accessories built for the standard shoe, unless you use one of the adapters that are available.

Neck
strap ring

Mode
dial

Accessory/
Flash hot shoe

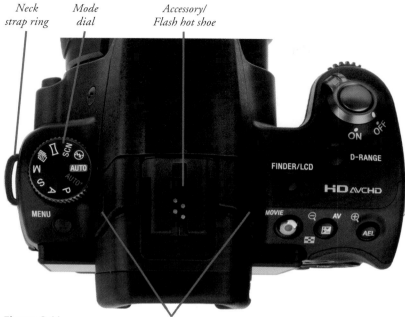

Figure 2.11 *Microphones*

■ **Microphones.** These two small groups of openings on either side of the viewfinder assembly house the right and left microphones that record the stereo sound for your movies. Be careful not to cover these holes with your hand or anything else while recording a movie.

■ **Neck strap rings.** Attach your strap to these two anchor points.

On the right side of the camera, you can see a cluster of controls, labeled in Figure 2.12.

■ **Power switch.** Rotate all the way clockwise to turn the Alpha on; in the opposite direction to switch it off.

■ **Control dial.** This dial on the front of the camera is used to make many shooting settings and can be used to navigate through menus. In Manual exposure mode, the control dial is used to set shutter speed; press the exposure compensation button while spinning the control dial to set aperture. In Shutter priority and Aperture priority modes, this dial is used to set the shutter speed or aperture, respectively. In Playback mode, the dial advances through your images.

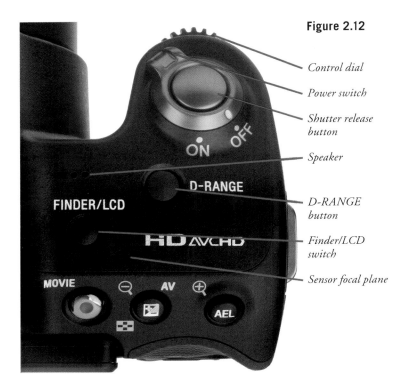

Figure 2.12

Control dial

Power switch

Shutter release button

Speaker

D-RANGE button

Finder/LCD switch

Sensor focal plane

- **Shutter release button.** Partially depress this button to lock in exposure and focus. Press all the way to take the picture. Tapping the shutter release when the camera has turned off the autoexposure and autofocus mechanisms reactivates both. When a review image is displayed on the back-panel color LCD, tapping this button removes the image from the display and reactivates the autoexposure and autofocus mechanisms.

- **Finder/LCD switch.** Press this button to switch between using the electronic viewfinder and using the LCD to view recording information and the Live View of the scene in front of the camera. With the default settings, the Eye-Start sensors make this switch automatically. However, if those sensors are turned off through the menu system, you can use this button to change between viewing methods.

- **D-RANGE button.** Pressing this button gives you instant access to the Dynamic Range Optimizer function, which can also be accessed through the Function button menu. This feature gives you added control over the highlights and shadows in your images.

- **Speaker.** This small group of holes marks the location of the speaker, from which emanate the beeps your camera makes, as well as the audio for your movies.

- **Sensor focal plane.** Precision macro and scientific photography sometimes requires knowing exactly where the focal plane of the sensor is. The symbol etched on the top of the camera, to the right rear of the Finder/LCD button, marks that plane.

Underneath Your Sony Alpha

The bottom panel of your Sony Alpha is pretty bare. You'll find a tripod socket, which secures the camera to a tripod, and the door to the battery/memory card compartment, which has a smaller door inset for plugging in an AC adapter.

- **Memory card/battery compartment slot cover.** This hinged panel protects your memory card slot and battery compartment from dust and dirt when they're not in use. Keep it closed except when you're inserting or removing a card or a battery.

- **Tripod socket.** Attach the camera to a tripod, monopod, or other support using this standard receptacle.

- **Connection plate cover.** This little door has to be opened up from underneath, when the battery/memory card compartment door is open. The connection plate cover has to be opened when you install the Sony AC adapter that fits this camera, model number AC-PW20. The power cord fits through the small opening made by opening this door; the adapter includes a component shaped like the camera's battery, which fits inside the battery compartment and attaches to that cord.

Lens Components

There's not a lot going on with most Sony lenses in terms of controls because, in the modern electronic age, most of the functions previously found in lenses in the ancient film era, such as autofocus options and (maybe) image stabilization features, are taken care of by the camera itself. Figure 2.13 shows a Sony DT 18-70mm f/3.5-5.6 lens and its components. I'm also going to mention some other features not found in this particular lens.

- **Lens hood bayonet.** This is used to mount the lens hood for lenses that don't use screw-mount hoods (the majority).

- **Zoom ring.** Turn this ring to change the zoom setting.

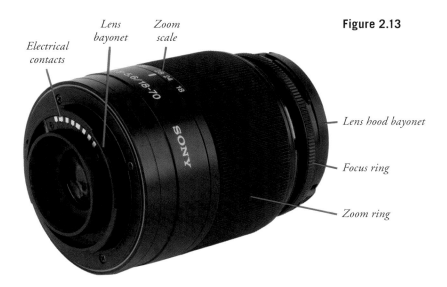

Figure 2.13

- **Zoom scale.** These markings on the lens show the current focal length selected.
- **Focus ring.** This is the ring you turn when you manually focus the lens.
- **Electrical contacts.** On the back of the lens are electrical contacts that the camera uses to communicate focus, aperture setting, and other information.
- **Lens bayonet.** This mount is used to attach the lens to a matching bayonet on the camera body.
- **AF/MF switch (not shown).** Some Sony lenses have a switch to choose between autofocus and manual focus; some do not. With the Sony Alpha SLT-series, you need to switch focus modes on the lens, if it has such a switch. In that case, leave the AF/MF switch on the camera set to AF at all times, and switch to MF or AF using the switch on the lens. If the lens does not have such a switch, then you need to use the switch on the camera to change from autofocus to manual focus and vice-versa.
- **Filter thread (not shown).** Lenses (including those with a bayonet lens hood mount) have a thread on the front for attaching filters and other add-ons. Some also use this thread for attaching a lens hood (you screw on the filter first, and then attach the hood to the screw thread on the front of the filter). Both the 18-70 and 18-55mm standard zoom lenses from Sony have a 55mm filter thread, not shown in this figure.

■ **Distance scale (not shown).** Some upscale lenses, including the Zeiss optics, have this readout that rotates in unison with the lens' focus mechanism to show the distance at which the lens has been focused. (The illustrated lens does not have a distance scale.) It's a useful indicator for double-checking autofocus, roughly evaluating depth-of-field, and for setting manual focus guesstimates.

LCD Panel Readouts

The Sony Alpha's generously expansive 3-inch color LCD shows you everything you need to see, from images to a collection of informational data displays. Here's an overview of these displays. When you're using the Live View on the LCD, you can choose among four different displays of recording information, selected by successive presses of the DISP button: a graphic display with basic recording information, a standard display with full recording information, a display showing only basic recording information, and a display showing basic recording information and the electronic level (no level is available with the A35).

The only screen that shows the full amount of recording information is what I call the standard display, which appears only on the LCD. It appears in two versions: one that overlays the information over the Live View, and another that displays the information against a dark background, without the Live View. The latter screen can be selected using the Display Recording Data option on the Custom 2 menu. The items that appear on these two displays are described below.

■ **Exposure mode.** Shows whether you're using Program auto, Aperture priority, Shutter priority, Manual, or one of the auto, Scene, or specialized modes. (If the camera is set to Auto or any of the other Scene modes, the information shown on the two recording information displays is considerably less than the full amount that appears in the P, A, S, or M modes.)

■ **Image quality.** Your image quality setting (JPEG Fine, JPEG Standard, RAW, or RAW & JPEG).

■ **Image size/Aspect ratio.** Shows whether you are shooting Large, Medium, or Small resolution images, and whether the Alpha is set for the 3:2 aspect ratio or wide-screen 16:9 aspect ratio (the image size icon changes to a "stretched" version when the aspect ratio is set to 16:9). If you're shooting RAW images, there is no symbol shown, because all RAW images are the same size and no size choice is available.

■ **Memory card.** This icon appears when a memory card (either SD or Memory Stick) is present in the camera.

- **Remaining exposures.** Shows the approximate number of shots available to be taken on the memory card, assuming current conditions, such as image size and quality.
- **Movie resolution.** This icon gives the movie file format and resolution. The choices are: FH, for Full High Definition (AVCHD) at 1920 × 1080 pixels; 1080, for MP4 at 1440 × 1080; and VGA, for MP4 at 640 × 480.
- **Battery status.** Remaining battery life is indicated by this icon.
- **Flash mode.** Provides flash mode information. The possible choices are Flash Off, Autoflash, Fill-flash, Slow Sync, Rear Sync, and Wireless. Not all of these choices are available at all times.
- **Drive mode.** Shows whether camera is set for Single-shot, Continuous shooting (Low- or High-speed), Self-timer, Exposure Bracketing, White Balance Bracketing, or Remote Commander.
- **Autofocus mode.** Tells whether AF-S, AF-C, or AF-A autofocus mode is active, as described in Chapter 1.
- **Autofocus area.** Shows the AF area mode in use: Wide (the camera chooses one or more of the 15 AF areas to use); Spot (the camera uses the center AF area exclusively); or Local (you select which of the 15 areas to use).
- **White balance.** Shows current white balance setting. The choices are Auto White Balance, Daylight, Shade, Cloudy, Incandescent, Fluorescent, Flash, Color Temperature, and Custom.
- **D-Range Optimizer.** Indicates the type of D-Range optimization (highlight/shadow enhancement) in use, either Off, Auto, Level 1 through 5, or Auto HDR.
- **Creative Style.** Indicates which of the six Creative Style settings (Standard, Vivid, Portrait, Landscape, Sunset, or Black and White) is being applied.
- **ISO setting.** Indicates the sensor ISO sensitivity setting, either Auto ISO or a numerical value from 100 to 12800. This icon also may indicate that Multi Frame Noise Reduction is in effect, in which case the ISO icon includes a stack of multiple rectangular frames.
- **Metering mode.** The icons represent Multi segment, Center weighted, or Spot metering.
- **Flash exposure compensation.** This icon is shown whenever the built-in flash is popped up or a compatible external flash is attached to the hot shoe. On the display without Live View, the icon appears next to the exposure compensation scale, and an indicator appears below the scale to show how much flash exposure compensation is being applied, if any. On

the display with Live View, the amount of flash exposure compensation is shown only by a number below the icon.

■ **Exposure value scale.** On both the standard and graphic displays, this scale is displayed along with an indicator to show the amount of exposure compensation that is being applied. In Manual exposure mode, on the display without Live View, the icon next to this scale changes to the M.M. icon, meaning that manual metering is in effect. On the display without Live View, whenever the built-in flash is popped up or a compatible flash is attached to the hot shoe, another indicator appears below the scale along with the flash exposure compensation symbol, to indicate how much flash exposure compensation, if any, is being applied.

■ **Shutter speed.** Shows the current shutter speed.

■ **Aperture.** Displays the current f/stop.

■ **Exposure compensation.** On all of the information displays, the amount of exposure compensation, even if zero, is shown by an indicator on the EV scale. On the full display without Live View, if there is some exposure compensation, in addition to the scale, a number appears at the bottom right of the screen indicating the positive or negative amount of compensation.

■ **AEL button status.** An asterisk is displayed here whenever the AEL button is activated, whether it is being used to lock the exposure setting or to allow the use of the control dial to vary the settings of aperture and shutter speed in Manual exposure mode (the "Manual Shift") feature.

■ **SteadyShot status (with Live View).** Shows whether the Alpha's anti-shake features are turned on or off.

■ **SteadyShot scale (without Live View).** This scale of bars shows how much camera shake is present. Wait until the bars subside as much as possible before shooting.

■ **Shutter speed indicator (graphic display only).** Graphically illustrates that faster shutter speeds are better for action/slower for scenes with less movement.

■ **Aperture indicator (graphic display only).** Icons indicate that wider apertures produce less depth-of-field (represented by a "blurry" background icon).

■ **Face Detection.** When this feature is activated, the camera attempts to detect faces in the scene before it, and, if it does, it adjusts autofocus and exposure accordingly.

■ **Smile Shutter.** With this feature turned on, the camera will automatically trigger the shutter when the subject smiles. I discuss its operation in Chapter 3.

When reviewing images you've taken (press the Playback button to summon the last shot exposed to the LCD), the Alpha shows you a picture for review; you can select from among three different information overlays. To switch among them, press the DISP button while the image is on the screen. The LCD will cycle among the Single-image display with no extra data at all; Single-image display with recording data (Figure 2.14); and a Histogram display, which shows basic shooting information as well as a brightness histogram at bottom right, with individual histograms for the red, green, and blue channels (Figure 2.15).

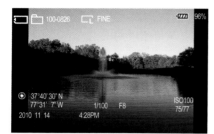 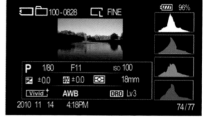

Figures 2.14, 2.15 Image playback displays include Single-image, Single-image with recording information, and Histogram view.

Looking Inside the Viewfinder

One thing that distinguishes the Sony Alpha SLT-A55, A33, and A35 from other cameras in their general class is that, because of the unique translucent-mirror technology used in these cameras, there is no need for a moving mirror, and therefore the Live View can be sent to both the LCD, electronic viewfinder, and the focusing mechanism at all times. The LCD and the electronic viewfinder can show exactly the same images; there is no meaningful difference between what you can see in the viewfinder window and what can be shown on the LCD. However, the viewfinder display has only three available screens: the graphic display, the display of basic recording information, and the electronic level. The viewfinder does not show the full recording information display that is available on the LCD, either with or without the Live View.

Chapter 3

Setting Up Your Sony Alpha SLT

The Sony Alpha camera has a remarkable number of options and settings you can use to customize the way it operates. Not only can you change shooting settings used at the time the picture is taken, but you can adjust the way your camera behaves. This chapter will help you sort out the settings on the Recording and Playback menus (which determine how the Alpha uses many of its shooting features to take a photo and how it displays images on review) and the Setup and Custom menus (to adjust power-saving timers, specify LCD brightness, and adjust options like Eye-Start autofocus and red-eye reduction). I'll also include the Memory Card Tool and Clock setup menus.

Anatomy of the Sony Alpha's Menus

The Sony Alpha series has an array of 11 separate tabbed menus (for the SLT-A55/A33), or 12 for the A35. Each has a single screen of entries, arranged in rows. You'll never need to scroll within a menu to see all the entries; however, if you scroll down to the bottom of any given menu, and then past the last entry, you'll be taken automatically to the first entry in the next tab. Just press the MENU button, located in the upper-left corner of the back of the camera, use the left/right controller buttons to highlight the menu tab you want to access, and then use the up/down buttons or spin the control dial to highlight the menu entry you want.

Pressing the MENU button brings up a typical menu. (If the camera goes to "sleep" because of the Power Save feature while you're reviewing a menu, you can wake it up again by tapping the MENU button.) The 11 (or 12) menu tabs are Recording 1, Recording 2, Recording 3, Custom 1, Custom 2, Playback 1, Playback 2, Memory Card Tool, Clock setup, Setup 1, and Setup 2. The A35

has an additional tab, Setup 3. Although the menus are virtually identical among these three cameras, I'm going to illustrate this chapter and the next using the "latest" model in the line, the A35.

When working with any of these menus, after you've moved the highlighting bar with the up/down buttons (or the control dial) to the menu item you want to work with, press the center controller button to select it. In most cases, a submenu with a list of options for the selected menu item will appear. Within the submenu options, you can scroll with the up/down buttons or with the control dial to choose a setting, and then press the center controller button to confirm the choice you've made. Press the MENU button again to exit. Or, if you prefer, you can press halfway down on the shutter button to exit the menu system and go directly into Recording mode, ready to snap a photo with your new menu settings. At times you will notice that some lines on various menu screens are "grayed out," so you can read them, but that item is not available for adjustment with your current settings.

Recording 1/2/3 Menu

The various settings accessed through the buttons on the Alpha for Drive mode, ISO, D-Range Optimizer, white balance, and exposure compensation are likely to be the most common settings you make, with changes during a particular session fairly common. Some of the settings are accessible through the Fn button or direct buttons, but several of the camera's most important settings are available only through the menu system, including image size, quality, and aspect ratio. Figure 3.1 shows the Recording 1 menu.

This section explains the options of the three Recording menu screens and how to use them. The choices you'll find on these screens include the following:

- Image: Size
- Image: Aspect Ratio
- Image: Quality
- Movie: File Format
- Movie: Size
- Movie: Audio Rec.
- SteadyShot
- Panorama: Size
- Panorama: Direction

- 3D Pan.: Image Size
- 3D Pan.: Direction
- Flash Control
- AF Illuminator
- Color Space
- Long Exposure NR
- High ISO NR
- D-RANGE button (A35 only)

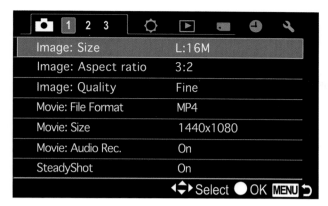

Figure 3.1
The Sony Alpha's Recording 1 menu.

Image: Size

Options: Large, Medium, and Small

Default: L (Large)

Here you can choose from the A55/A35/A33's Large, Medium, and Small image settings. Select the menu option, and use the up/down controller buttons or the control dial to choose L, M, or S. Then press the center controller button to confirm your choice. Of course, the resolution of each of these options depends on whether you're working with the A33, which has a maximum resolution of 14.2 MP, or the A55/A35, which have 16.2 MP, and whether you're using the standard 3:2 aspect ratio or the optional 16:9 HDTV aspect ratio (described next). Table 3.1 provides a comparison.

Image: Aspect Ratio

Options: 3:2, 16:9 aspect ratios

Default: 3:2

The aspect ratio is simply the proportions of your image as stored in your image file. The standard aspect ratio for digital photography is approximately 3:2; the image is two-thirds as tall as it is wide. These proportions conform to those of the most common snapshot size in the USA, 4 × 6 inches. Of course, if you want to make a standard 8 × 10-inch enlargement, you'll need to trim some image area from either end, or use larger paper and end up with an 8 × 12-inch print. Aspect ratios are nothing new for 35mm film photographers (or those lucky enough to own a "full-frame" digital SLR). The 36 × 24mm (or 24 × 36mm) frame of those cameras also has a 3:2 (2:3) aspect ratio.

Table 3.1 Image Sizes Available

SLT-A55/A35	Megapixels 3:2 Aspect Ratio	Resolution 3:2 Aspect Ratio	Megapixels 16:9 Aspect Ratio	Resolution 16:9 Aspect Ratio
Large (L)	16 MP	4912 × 3264	14 MP	4912 × 2760
Medium (M)	8.4 MP	3568 × 2368	7.1 MP	3568 × 2000
Small (S)	4.0 MP	2448 × 1624	3.4 MP	2448 × 1376
SLT-A33				
Large (L)	14 MP	4592 × 3056	12 MP	4592 × 2576
Medium (M)	7.4 MP	3344 × 2224	6.3 MP	3344 × 1872
Small (S)	3.5MP	2288 × 1520	2.9 MP	2288 × 1280

If you're looking for images that will "fit" a wide-screen computer display or a high-definition television, the Alpha models can be switched to a 16:9 aspect ratio that is much wider than it is tall. The camera performs this magic by cutting off the top and bottom of the frame, and storing a reduced resolution image (as shown in Table 3.1). Your 16 MP image becomes a 14 MP shot with the A55/A35, and a 14 MP photograph from the A33 is trimmed to 12 MP. If you need the wide-screen look, the 16:9 aspect ratio will save you some time in image editing, but you can achieve the same proportions (or any other aspect ratio) by trimming a full-resolution image in your editor. As with the other basic menu choices in this chapter, just navigate to the entry, press the center controller button, choose the option you want, and press the center controller button again to confirm your choice.

Image: Quality

Options: RAW, RAW & JPEG, Fine, Standard

Default: Fine

You can choose the image quality settings used by the Alpha to store its files. You have several choices to select from within this menu entry: RAW, RAW & JPEG, Fine, and Standard. (The two latter options are JPEG formats.) Here's what you need to know to choose intelligently:

■ **JPEG compression.** To reduce the size of your image files and allow more photos to be stored on a given memory card, the Alpha uses JPEG compression to squeeze the images down to a smaller size. This compacting reduces the image quality a little, so you're offered your choice of Fine

compression and Standard compression. Fine should really be your *standard*, because it offers the best image quality of the two JPEG options.

■ **JPEG, RAW, or both.** You can elect to store only JPEG versions of the images you shoot (Fine or Standard), or you can save your photos as RAW files, which consume several times as much space on your memory card. Or, you can store both file types at once as you shoot. Many photographers elect to save *both* a JPEG and a RAW file (RAW & JPEG), so they'll have a JPEG version that might be usable as-is, as well as the original "digital negative" RAW file in case they want to do some processing of the image later. You'll end up with two different versions of the same file: one with a .jpg extension, and one with the .arw extension that signifies a Sony RAW file. The JPEG files will be stored in Fine quality and Large size.

Movie: File Format

Options: AVCHD, MP4

Default: AVCHD

The Sony Alpha SLT-A55/A35/A33 offer full high-definition video recording in the AVCHD format in addition to the somewhat lesser quality MP4 format. If you select AVCHD, which is the default choice, you have no other choices to make for the movie image parameters—AVCHD provides only one image size of 1920 × 1080 pixels. If you select MP4, you have two choices of image size (see below).

Movie: Size

Options: 1440 × 1080, VGA (640 × 480)

Default: 1440 × 1080

This setting is available only if you have selected MP4 for the movie file format; as I discussed directly above, if you select AVCHD for the file format, there is only one image size available. The default setting for MP4 image size is 1440 × 1080, a high-quality format. Your other option is VGA, which you can use if you need to save space on your memory card or don't need the higher quality.

Movie: Audio Rec.

Options: On, Off

Default: On

This setting lets you turn off the audio recording for your movies. You might want to do this if you are certain you don't want to have any sound recorded,

or if you believe you might be bothered by sounds from the operation of the camera or lens that might be recorded. In my case, I always leave audio recording enabled, because you can always erase a soundtrack that you don't want or replace it with a new one, but you can never recover sounds that you didn't record in the first place.

SteadyShot

Options: On/Off

Default: On

This entry can be used to switch off the SteadyShot image stabilization feature. You might want to do that when the camera is mounted on a tripod, as the additional anti-shake feature is not needed in that situation, and slight movements of the tripod can sometimes "confuse" the system. However, it's rarely necessary to turn SteadyShot off, and I recommend leaving it turned on at all times unless you find that it causes problems in some specific situations.

Panorama: Size

Options: Standard, Wide

Default: Standard

This is the first option on the Recording 2 menu. (See Figure 3.2.) This setting is available only when the shooting mode is set to Sweep Panorama. In this case, there are only two options—the default choice of Standard, or the optional setting of Wide. With the Standard setting, if you are shooting a horizontal panorama, the size of your images will be 8192 × 1856 pixels; if your shots are vertical, the size will be 2160 × 3872 pixels. With the Wide setting, horizontal panoramas will be at a size of 12416 × 1856 pixels, and vertical shots will be 2160 × 5536 pixels.

Panorama: Direction

Options: Right, Left, Up, Down

Default: Right

When the shooting mode is set to Sweep Panorama, you have four options for the direction in which the camera will prompt you to pan or tilt the camera: Right, Left, Up, or Down. You have to select one of these so the camera will know ahead of time how to perform its in-camera processing of the images that it will stitch together into the final panorama. The default, Right, is probably the most natural to sweep the camera, but you may have occasions to use the

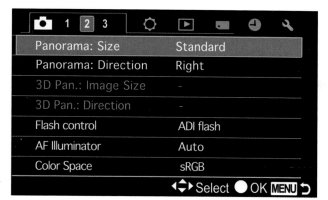

Figure 3.2
The Sony Alpha's
Recording 2
menu.

others, depending on the scene to be photographed. You can set this option only when the shooting mode is set to Sweep Panorama.

3D Pan.: Image Size

Options: 16:9, Standard, Wide

Default: 16:9

This setting is available only when the camera's shooting mode is set to 3D Panorama. Select from 16:9, Standard, and Wide for the size of the resulting panoramic image. Note that with this mode you get the additional ability to shoot with the 16:9 aspect ratio, as opposed to just the Wide and Standard options that are available for non-3D panoramas. This option lets you shoot normal-sized images in 3D, rather than only panoramas. With the 16:9 setting, the panorama's size is 1920 × 1080 pixels; with the Standard setting, the size is 4912 × 1080 pixels; with the Wide setting, the size is 7152 × 1080 pixels. The orientation is limited to horizontal in all cases.

3D Pan.: Direction

Options: Right, Left

Default: Right

This menu option is available only if you have set your shooting mode to 3D Panorama. The choice here is very simple: select either right or left for the direction in which the camera will prompt you to pan when shooting a 3D Panorama. (Unlike the normal Sweep Panorama mode, 3D Panorama images cannot be shot vertically.)

Flash Control

Options: ADI flash, Pre-flash TTL

Default: ADI flash

This is a technical setting that can be left untouched unless you happen to know you have a need to change it. ADI stands for Advanced Distance Integration. When you are using a lens that includes a distance encoder, this function may result in more accurate computation of the flash output. I discuss this option in Chapter 4.

AF Illuminator

Options: Auto, Off

Default: Auto

The AF illuminator is a pre-flash that fires when there is insufficient light for the Alpha's autofocus mechanism to zero in. This light emanates from either the built-in flash unit or a compatible external flash, if one is attached to the hot shoe. In the automatic and Scene modes, the built-in flash will pop up on its own if necessary for this purpose. The extra blast from the AF illuminator helps the camera focus sharply. The default setting, Auto, allows the AF illuminator to work any time the camera judges that it is necessary. Turn it off when you want to use flash but would prefer not to use this feature. The AF illuminator doesn't work when using AF-C focus mode, or when AF-A autofocus is used with a moving subject (which means it has shifted into AF-C mode). Nor will it work when the Smile Shutter is turned on, or with lenses with focal lengths and zoom settings of 300mm or longer.

Color Space

Options: sRGB/Adobe RGB

Default: sRGB

The Alpha's Color Space option gives you two different color spaces (also called *color gamuts*), named Adobe RGB (because it was developed by Adobe Systems in 1998), and sRGB (supposedly because it is the *standard* RGB color space). These two color gamuts define a specific set of colors that can be applied to the images your Alpha captures. You might want to use Adobe RGB when you plan on doing extensive editing to an image, while sRGB more closely matches the color range of your home inkjet printer, and those of most retailers' print kiosks.

Long Exposure NR/High ISO NR

Options: Long Exp.: On/Off; Default: On

Options: High ISO NR: Auto/Weak; Default: Auto

These two menu options are the first two entries on the Recording 3 menu with the A35, or the only two entries with the A55/A33 (see Figure 3.3). I've grouped them together because they work together, each under slightly different circumstances. Moreover, the causes and cures for noise involve some overlapping processes.

Your Alpha can reduce the amount of grainy visual noise in your photo, but, at the same time, eliminate some of the detail along with the noise. These two menu choices let you choose whether or not to apply noise reduction to exposures of one second or longer and how much noise reduction to apply to exposures made at high ISO settings (ISO 1600 and above). Although noise reduction is usually a good thing, it's helpful to have the option to turn it off or minimize it when you want to preserve detail, even if it means putting up with a little extra noise.

You might want to turn off noise reduction for long exposures and minimize it for high ISOs to preserve image detail, and when the delay caused by the noise reduction process (it can take roughly the same amount of time as the exposure itself) interferes with your shooting. Or, you simply may not need NR in some situations. For example, you might be shooting waves crashing into the shore at ISO 100 with the camera mounted on a tripod, using a neutral-density filter and long exposure to cause the pounding water to blur slightly. To maximize detail in the non-moving portions of your photos, you can switch off long exposure noise reduction. Note, though, that the menu option for setting the amount of high ISO noise reduction is grayed out and

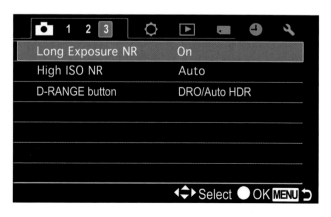

Figure 3.3
The Sony Alpha A35's Recording 3 menu. (The A55 and A33 lack the D-RANGE button entry.)

unavailable when shooting in RAW quality. (If you shoot in RAW & JPEG, the JPEG images, but not the RAW files, will be affected by this setting.) Long exposure noise reduction will not operate, even if these menu options are turned on, if the shooting mode is set to Sweep Panorama, Continuous Advance Priority AE, continuous shooting, continuous bracketing, or Hand-held Twilight. Long exposure noise reduction also does not operate when ISO is set to Multi Frame Noise Reduction. When the shooting mode is set to any of the Auto or Scene modes, long exposure noise reduction cannot be turned off.

High ISO noise reduction is automatically set to Weak during continuous shooting or continuous bracketing. You cannot select Weak for this setting in the Auto, Scene, or Sweep Panorama shooting modes.

D-RANGE button

Options: White Balance/DRO-Auto HDR/Creative Style

Default: DRO-Auto HDR

Use this menu entry, available only with the A35, to change the behavior of the D-RANGE button, located just southwest of the On/Off switch on top of the camera. With the default setting, when you press the D-RANGE button, the D-Range Optimizer screen appears on the LCD or in the viewfinder. When the D-Range Optimizer screen is visible, you can use the controller keys to select Off (no contrast and highlight adjustments will be made); D-Range Optimizer (the A35 analyzes the scene and produces an image with optimal brightness and tones); or Auto HDR, which shoots three images with different exposures, and then overlays the correctly exposed image, the bright areas of an under exposed image, and the dark areas of an over exposed image to create an image with rich gradation. Two images are recorded: an image with the correct exposure and an overlaid image.

If you feel you don't need quick access to these choices through the D-RANGE button, you can redefine the button to produce either the White Balance or Creative Style options screens instead. You can always select the D-RANGE Optimizer options using the Fn menu.

Custom 1/2 Menu

The options on the two Custom menu screens allow you to specify how your Alpha operates. If you find the Eye-Start autofocus feature distracting, you can change it here. If you'd like to change the length of time that a newly captured image is displayed on the LCD, you can choose that behavior.

There are 13 menu entries overall in the Custom menu. The first screen is shown in Figure 3.4.

- Eye-Start AF
- FINDER/LCD Setting
- AEL Button
- Focus Hold Button
- Focus Magnifier
- Red Eye Reduction
- Release w/o Lens
- Grid Line

- Histogram
- Sets Display in Finder (available on the A35 only)
- Display Rec. Data
- Auto Review
- Auto+ Cont. Advance
- Auto+ Image Extract

Eye-Start AF

Options: On, Off

Default: Off

It's great how the Sony Alpha is able to read your mind and start autofocusing the instant you move the viewfinder to your eye. The image on the LCD vanishes, the camera adjusts autofocus, and, if you've selected any exposure mode other than Manual, it sets shutter speed and/or aperture for you. You don't even have to partially depress the shutter release. Of course, it's not magic. There are two sensors just below the viewfinder window that detect when your face (or anything else) approaches the finder. Of course, some people find this feature annoying. The camera may turn off the LCD and switch on autofocus when a stray hand or other object passes near the viewfinder, and it uses a significant amount of battery power. If you choose to, you can turn off Eye-Start AF using this menu setting.

Figure 3.4
The Sony Alpha's Custom 1 menu.

FINDER/LCD Setting

Options: Auto, Manual

Default: Auto

This option is somewhat similar to the Eye-Start setting, above, though this setting controls only whether the camera turns off the LCD and switches the view to the viewfinder when your eye comes near the viewfinder. With the default setting of Auto, the screen goes blank and the viewfinder activates when your eye approaches the Eye-Start sensors. With the Manual setting, you have to use the FINDER/LCD button, to the right of the viewfinder, to switch the view. You might want to use this setting if you are doing work involving critical focusing, and you need to examine the LCD closely without having it turn off whenever your face gets too close to the screen.

AEL Button

Options: AEL hold, AEL toggle

Default: AEL hold

This option affects the operation of the AEL (auto exposure lock) button, located at the top of the camera's back, at the far right. With the default setting, AEL hold, when you press the AEL button your exposure is locked only as long as you hold down the button. If you set this option to AEL toggle, then you can just press the button and release it, and the exposure will stay locked until you press and release it again.

Focus Hold Button

Options: Focus Hold, D.O.F. Preview

Default: Focus Hold

This function is of use only when you are using a lens equipped with a focus hold button. This setting specifies the effect of pressing that button. With the default, Focus Hold, pressing the button on the lens holds the focus at its current setting. The other two settings let you use that button to activate a depth-of-field preview, which causes the lens to stop down to the actual shooting aperture so you can more accurately judge the depth-of-field that will be obtained at that aperture. The preview button is still available for the DOF function.

Focus Magnifier

Options: On, Off

Default: Off

When you turn this option on, the Trash button at the lower right of the camera's back takes on a second identity as the Focus Magnifier button. With this option, whenever you are focusing, either with autofocus or manual focus, pressing the Trash button magnifies the image on the LCD or in the electronic viewfinder so you can judge the sharpness of the focus more clearly. When you press the button once, a small orange rectangle appears. Move that rectangle around the image to the part you would like to enlarge, using the controller buttons. Then press the button again, and that part of the image is magnified about 7-7.5 times on the SLT-A55/A35/A33. Press once more and the magnification levels rise to 14 and 15 times, respectively. Press it again, and the image reverts to its normal size.

Red Eye Reduction

Options: On, Off

Default: Off

It's fairly easy to remove red-eye effects in an image editor (some image importing programs will do it for you automatically as the pictures are transferred from your camera or memory card to your computer). But, it's better not to have glowing red eyes in your photos in the first place. When this feature is activated, the Alpha's flip-up flash issues a few brief bursts prior to taking the photo, theoretically causing your subjects' pupils to contract, reducing the effect (assuming the person is looking at the camera during the bursts). This option works only with the built-in flash, and doesn't produce any prebursts if you have an external flash attached. In most cases, the higher elevation of the external flash effectively prevents red eye anyway.

Release w/o Lens

Options: Enable, Disable

Default: Disable

When this option is enabled, it's possible to release the shutter when no lens is attached to the camera. This feature is needed when you have attached the camera body to some other piece of equipment, such as a telescope, for astrophotography or a similar activity. If you're not doing something that clearly requires this option, you should leave it disabled to avoid causing problems for your camera's delicate inner workings.

Grid Line

Options: Off, Rule of 3rds Grid, Square Grid, Diag. + Square Grid

Default: Off

This feature, the first item on the Custom 2 menu screen (see Figure 3.5), lets you choose from three possible configurations of composition aids on the camera's screen. The Rule of 3rds Grid option puts two pairs of parallel lines on the screen, dividing the image into 9 parts. If you place the most important part of your composition near the intersections of these lines, you will be observing the Rule of Thirds, which calls for offsetting the main features of the photograph away from the center. The Square Grid uses five lines in each direction, yielding 25 blocks, which allows for more precise placement of the components of your shot. Finally, the Diag. + Square Grid option uses a four-by-four square with diagonal lines intersecting in the center of the image, giving you a few more options for alignment of the elements of your composition.

Figure 3.5
The Sony Alpha's Custom 2 menu.

Histogram

Options: On, Off

Default: Off

When playing back your still images on the LCD, one of the screens accessed with the DISP button includes a histogram, which shows the distribution of brightness values in your image. The Histogram menu option on the Custom 2 menu lets you also turn on a histogram display while you are shooting still images, to help you determine whether the image will be exposed as you want it. If you turn this option on, the screen with the histogram takes the place of

the graphic display in the sequence of screens that result from pressing the DISP button. On this screen, a small histogram, showing only brightness, and not color values, will appear in the lower right of the LCD (or in the viewfinder) while you are shooting non-panorama still images.

Sets Display in Finder

Options: Always, When Operating

Default: Always

This option, available with the A35 only, lets you choose whether the shutter speed, aperture setting, EV scale, and SteadyShot scale are displayed in the viewfinder. When set to Always (the default), these indicators are present any time you are looking through the viewfinder. If you find all that information distracting when composing an image, you can select When Operating, and the indicators will be shown only when you are adjusting exposure. The information is still visible on the back panel LCD, even if you've turned off the Always option for the viewfinder.

Display Rec. Data

Options: For Live View, For Viewfinder

Default: For Live View

Each time you press the DISP button while in Recording mode, the camera shows one of four screens on the LCD: graphic display, full information, basic information, and electronic level (not available on the A35). This menu option changes the appearance of the full information screen. With the default choice, For Live View, the full information appears overlaid over the Live View image, so you can see the composition on the LCD. With the other option, For Viewfinder, the LCD displays the full recording information only, set on a dark background; to see the image itself, you have to look into the viewfinder.

Auto Review

Options: Off, 2 seconds, 5 seconds, 10 seconds

Default: Off

The Sony Alpha can display an image on the LCD for your review after the photo is taken. (When you shoot a continuous or bracketed series of images, only the last picture exposed is shown.) During this display, you can delete a disappointing shot by pressing the Trash button, or cancel picture review by

tapping the shutter release, or performing another function. (You'll never be prevented from taking another picture because you were reviewing images on your LCD.) This option can be used to specify whether the review image appears on the LCD for 2, 5, or 10 seconds, or not at all. Even if you have Auto review turned on, if Eye-Start is activated and the camera is near your eye, the LCD remains off until you remove your eye from the viewfinder. You might want a quick display, or none at all when taking photos in a darkened theater. You can always review the last picture you took at any time by pressing the Playback button.

Auto+ Cont. Advance

Options: Auto, Off

Default: Auto

When the camera's shooting mode is set to AUTO+, the camera recognizes various Scene types and other shooting situations. With this menu option set to its default setting of Auto, the camera will take multiple shots when appropriate, such as when motion is detected. With this option turned off, the camera will take only single shots.

Auto+ Image Extract

Options: Auto, Off

Default: Auto

When the camera's shooting mode is set to AUTO+, the camera recognizes various Scene types and other shooting situations, and may take multiple shots in certain situations. This menu option gives you two choices for how the images are stored when the AUTO+ setting triggers multiple shots. With the default setting of Auto, the camera selects what it deems to be the most appropriate image of all those that were shot and stores only that one image. With the Off setting, the camera stores all of the multiple shots, leaving it up to you to select whichever one(s) you want to keep.

Playback 1/2 Menu

The Playback menu controls functions for deleting, protecting, displaying, and printing images. You can bring it up on your screen quickly by pressing the Playback button first, then the MENU button. Otherwise, you have to start

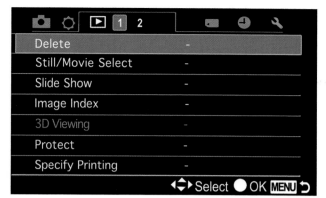

Figure 3.6
The Sony Alpha's
Playback 1 menu.

with the Recording menu and scroll over five tabs to the right. The first of the two screens of the Playback menu is shown in Figure 3.6.

- Delete
- Still/Movie Select
- Slide Show
- Image Index
- 3D Viewing
- Protect

- Specify Printing
- Volume Settings
- Select Folder
- Select Date
- Playback Display

Delete

Options: Multiple Img., All in Folder

Default: None

While you can delete a photo immediately after you take it by pressing the Trash button, this menu choice makes it easy to remove selected photos (Multiple Images), or to erase all the photos in a folder on a memory card (All in Folder). Note that neither function removes images marked Protected (described below in the section on "Protect").

To remove selected images, select the Delete menu item, and use the up/down keys or the control dial to choose the Multiple Images option from the submenu. Press the center controller button, and the most recent image appears on the LCD. Scroll through your images using the left/right controller keys or the control dial, and press the center controller button while an image that you

want to delete is displayed; a green trash can icon is superimposed over each marked image. The number of images marked for deletion is incremented in the indicator at the lower left of the LCD, next to a trash can icon. When you're satisfied (or have expressed your dissatisfaction with the really bad images), press the MENU button to go back, where you can choose Delete to erase the images you've marked.

While you can also use this menu choice to delete all the images in the current folder on the memory card by selecting the All in Folder option instead of the Multiple Images option, the process can take some time. If you have a large number of images on your memory card, you're better off using the Format command on the Memory Card Tool menu, described later in this chapter.

Still/Movie Select

Options: Still, Movie

Default: Still

On the SLT cameras, you cannot play back stills and movies in a single sequence; you need to select one or the other, for normal playback or for Slide Show display. There are three ways to select between stills and movies for these purposes. First, you can use this menu option, choosing either Still or Movie from the submenu. The second way is from the playback index screen, which I discussed in Chapter 1. On that screen, accessed by pushing the Zoom Out/ Index button during playback mode, you use the left controller button to navigate to the far left of the screen, then move up or down with the controller buttons to highlight either the icon for stills at the top of the screen, or the icon for movies at the bottom. (Of course, if you happen to have only movies or stills on your memory card, the choice is made for you, and this option is not available.) Finally, you can shift the camera into Still or Movie mode for this purpose by recording a quick still image or movie. In other words, if you want to display movies but don't want to go through either of the procedures outlined above, you can just press the red Movie button twice, which records a very short movie. This action shifts the camera into Movie mode for purposes of playback, so you can now press the Play button and you will be presented with the index of movies available to be played.

Slide Show

Menu Options: Enter, Cancel

Slide Show Options:

Interval: 1 second, 3 seconds, 5 seconds, 10 seconds, 30 seconds

Default: 3 seconds

Repeat: On, Off

Default: Off

Image Type: All, Display 3D Only

Default: All

This menu option allows you to display all the images on your memory card in a continuous show, using a three-second delay between images, or another delay period you select by choosing the Interval suboption. Choose 1, 3, 5, 10, or 30 seconds for your interval. Set the Repeat option on to make the show repeat continuously. If you have 3D images on your memory card, you can elect to include only those images in the show, or include all images. You cannot play back both still images and movies in the same slide show; you have to select one or the other, using the Still/Movie select methods discussed above, before setting up the slide show. During the show you can:

- Move forward or reverse in the show by pressing the controller left/right keys.

- Press the DISP button to toggle between full screen images and the same images overlaid with date, time, and image number.

- Stop the show at any time by pressing the MENU button, the Play button, or the center controller button. (There is no way to pause and resume the show.)

Image Index

Options: 6 Images, 12 Images

Default: 6 Images

Use this option to set the number of thumbnail images to be displayed when you press the Zoom Out/Index button during playback. After you have set the number to 6 or 12, you can press the MENU button to return to the menu, or you can press the center controller button if you want to go ahead and view the screen of thumbnail images.

3D Viewing

This option is not available unless you have connected your Sony Alpha to a 3D-capable HDTV to display your 3D Sweep Panorama images. You need to select this menu item to view 3D images, and when you select it, only 3D images will be viewed on the HDTV. To view other images, you need to exit from this viewing option.

Protect

Options: Multiple Images, Cancel All Images

Default: None

You might want to protect images on your memory card from accidental erasure, either by you or by others who may use your camera from time to time. To protect selected images, select the Protect menu item, and choose Multiple Images. Press the center controller button, and the images appear one by one on your LCD as you browse through them with the left/right controller buttons or with the control dial. When an image you want to protect is displayed, press the center controller button to mark it for protection (or to unmark an image that has already been marked). A green key icon appears over each marked image. When you've marked all the images you want to protect, press the MENU button to return to the menu screen, and then choose Enter to finish the protection operation.

Specify Printing

Options (DPOF Setup): Multiple Images, Cancel All (unmark all images)

Options (Number of Copies): 1-9

Options (Date Imprint): On, Off

Defaults: None

Most digital cameras are compatible with the DPOF (Digital Print Order Format) protocol, which enables you to mark in your camera which of the JPEG images on the memory card (but not RAW files) you'd like to print, and specify the number of copies of each that you want. You can then transport your memory card to your retailer's digital photo lab or do-it-yourself kiosk, or use your own compatible printer to print out the marked images and quantities you've specified. You can access the Specify printing options from this menu choice.

■ **DPOF setup.** You can choose to print Multiple Images or to Cancel All. Selecting images is similar to the method you use to mark images for deletion or protection. To print selected images, select the DPOF Setup option, press the center controller button, and choose Marked Images from the submenu. Then scroll down to the OK option, and press the center controller button to select it. You can then browse through the images you want to print, using the left/right controller keys or the control dial. For each image, press the center controller button to increment the number of prints to be made of that image, from 1 to 9. A printer icon in the lower-left corner shows the cumulative number of prints selected for all images. If you continue pressing the center controller button past 9 copies, the count wraps around to 0 copies again. That is the only way to reduce the number of copies, or to cancel the printing status of an individual image.

When finished marking images and specifying the numbers of copies, press the MENU button to exit picture selection. The Cancel All option at the top of the screen removes all DPOF print selection and quantity marks. This entry is useful if you print photos from a memory card, but then leave the images on the card while you shoot additional pictures. Removing the DPOF markings clears the card of print requests so you can later select additional or different images for printing from the same collection.

■ **Date imprint.** Choose this menu option to superimpose the current date onto images when they are printed. Select On to add the date; Off (the default value) skips date imprinting. The date is added during printing by the output device, which controls its location on the final print.

Volume Settings

Options: 0-7

Default: 2

This menu option is the first one on the Playback 2 menu. (See Figure 3.7.) It is available for selection only when you have at least one movie saved on your memory card, and the Still/Movie selection is set to Movie. Set the volume for movie playback to any setting from 0 (no sound) to 7 (loudest sound). You also can adjust the volume while a movie is playing, by pressing the down controller button, which pops up an on-screen volume control. You can then raise or lower the volume with the up/down keys or the control dial.

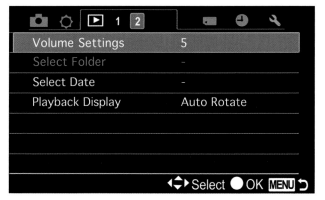

Figure 3.7
The Sony Alpha's
Playback 2 menu.

Select Folder

Options: Select Folder

Default: None

Use this menu option to view the images from a particular folder on your current memory card. When you select this option, you are presented with an inset box with up and down arrows; use the up/down controller keys to select the folder with the images you want to view, and press the center controller button to confirm your choice.

Select Date

Options: Dates of stored movies

Default: Latest date with at least one movie

This menu option is available only if you have selected movies to be played back, using either the Still/Movie menu option or one of the other methods discussed earlier, because, oddly enough, only movies, and not still images, are stored by date. Select this option and you are presented with a list of dates; select the one you want, and you can then play the movies that were recorded on that date.

Playback Display

Options: Auto Rotate, Manual Rotate

Default: Auto Rotate

When this item is set to Auto Rotate, the Sony Alpha rotates pictures taken in vertical orientation on the LCD screen so you don't have to turn the camera to

view them comfortably. However, this orientation also means that the longest dimension of the image is shown using the shortest dimension of the LCD, so the picture is reduced in size. Choose Manual Rotate instead, and you can rotate only those photos you want to re-orient, by pressing the Fn button when the image is displayed and choosing Rotate from the resulting screen.

Memory Card Tool Menu

The single-screen Memory Card Tool menu gives you ready access to several options that are all related to the storage of images on your SD or Memory Stick card. (See Figure 3.8.)

- Format
- File Number
- Folder Name
- Select REC Folder

- New Folder
- Recover Image DB
- Display Card Space

Format

Options: Enter, Cancel

Default: Cancel

To reformat your memory card, choose the Format menu entry and press the center controller button. Choose Enter when the "All data will be deleted. Format?" message appears.

Use this option to erase everything on your memory card, including Protected images, and set up a fresh file system ready for use. The Format command removes all the images on the memory card, and reinitializes the card's file system by defining anew the areas of the card available for image storage,

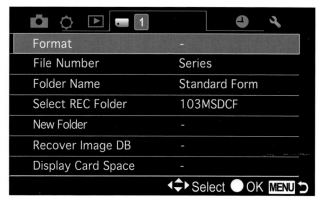

Figure 3.8
The Sony Alpha's Memory Card Tool menu.

locking out defective areas, and creating a new folder in which to deposit your images. It's usually a good idea to reformat your memory card in the camera (not in your camera's card reader using your computer's operating system) before each use. Formatting is much quicker than deleting images one by one.

File Number

Options: Series, Reset

Default: Series

The File Number option controls how the camera sets up the file numbers for your images. The Sony Alpha will automatically apply a file number to each picture you take when this option is set to Series, using consecutive numbering for all your photos over a long period of time, spanning many different memory cards, and even if you reformat a card. Numbers are applied from 0001 to 9999, at which time the camera starts back at 0001. The camera keeps track of the last number used in its internal memory. So, you could take pictures numbered as high as 100-0240 on one card, remove the card and insert another, and the next picture will be numbered 100-0241 on the new card. Reformat either card, take a picture, and the next image will be numbered 100-0242. Use the Series option when you want all the photos you take to have consecutive numbers (at least, until your camera exceeds 9999 shots taken).

If you want to restart numbering back at 0001 on a more frequent basis, set the Reset option. In that case, the file number will be reset to 0001 *each* time you format a memory card or delete all the images in a folder, insert a different memory card, or change the folder name format (as described in the next menu entry).

Folder Name

Options: Standard Form, Date Form

Default: Standard Form

If you have viewed one of your memory cards, contents on a computer using a card reader, you noticed that the top-level folder on the card is always named DCIM. Inside that folder is another folder created by your camera. Different cameras use different folder names, and they can co-exist on the same card. For example, if your memory card is removed from your Sony camera and used in, say, a camera from another vendor that also accepts Secure Digital or Memory Stick cards, the other camera will create a new folder using a different folder name within the DCIM directory.

By default, the Alpha creates its folders using a three-number prefix (starting with 100), followed by MSDCF. As each folder fills up with 999 images, a new folder with a prefix that's one higher (say, 101) is used. So, with the "Standard Form," the folders on your memory card will be named 100MSDCF, 101MSDCF, and so forth.

You can select Date Form instead, and the Alpha will use a *xxxymmdd* format, such as 10010204, where the 100 is the folder number, 1 is the last digit of the year, 02 is the month, and 04 is the day of that month. If you want your folder names to be more date-oriented, rather than generic, use the Date Form option instead of Standard Form.

Select REC Folder

Options: Select Folder

Default: Current Folder

If you have opted for the Standard Form for your storage folders using the above option, then you can use the Select REC Folder option to choose which folder to use for storage of your still images. (If you use Date Form, the images will be stored in folders according to their dates.) This option applies only to storage of still images, not movies.

New Folder

Options: New Folder

Default: None

This option gives you the ability to create a new folder for storing still images and movies. Select this menu item by pressing the center controller button on the New Folder menu line, and a message like "10110114 folder created" or "103MSDCF folder" appears on the LCD, depending on whether the Date Form or Standard Form for folders is in effect. Press the center controller button again to dismiss the screen and return to the menu.

Recover Image DB

Options: Enter, Cancel

Default: None

The Recover Image DB function is provided in case errors crop up in the camera's database that records information about your movies. According to Sony, this situation may develop if you have processed or edited movies on a computer and then re-saved them to the memory card that's in your camera. I have

never had this problem, so I'm not sure exactly what it would look like. But, if you find that your movies are not playing correctly in the camera, go ahead and try this operation. Highlight this menu option and press the center controller button, and the camera will prompt you, "Check Image Database File?" Press the center controller button to confirm, or the upper controller key to cancel.

Display Card Space

Options: Display Card Space

Default: None

With this option, the camera displays the number of still images that can be recorded on your memory card and the number of total minutes of movie recording that can fit on your memory card, using the current settings of image size, quality, etc. Of course, these figures are approximate and will change as conditions change.

Clock Setup Menu

The other new branch of the menu system added by Sony for these cameras is the very short Clock setup menu, which has only two entries. If you travel a good deal, you may find it convenient to be able to get quick access to these settings to adjust your current location so that the dates and times of your images and videos will be recorded accurately. This brief menu screen is shown in Figure 3.9.

- Date/Time Setup
- Area Setting

Figure 3.9
The Sony Alpha's Clock setup menu.

Date/Time Setup

Options: Daylight Savings Time, Year, Month, Day, Time, Date Format

Default: None

Use this option to specify the date and time that will be embedded in the image file along with exposure information and other data. You can select whether Daylight Savings Time is in effect or not, year, day, month, hour, minute, and date format, but you cannot choose AM/PM specifically. To set, say 2:32 AM or 2:32 PM, you'll have to pretend you're using a digital clock and cycle past midnight or noon to get to the AM/PM hours, respectively.

Area Setting

Options: World Time Zones

Default: None

When you select this option, you are presented with a world map on the LCD. Use the control wheel or the left/right controller buttons to scroll until you have highlighted the correct time zone. Once the camera is set up with the correct date and time in your home time zone, you can use this setting to change your time zone during a trip, so you will record the local time with your images without disrupting your original date and time settings. Just scroll back to your normal time zone once you return home.

Setup 1/2 Menus

Finally, the three screens of the Setup menu are populated with the less frequently changed settings, such as language, LCD brightness, and power saving settings. The Setup 1 menu for the A55V is shown in Figure 3.10. (The A35/A33 lack the GPS entry.)

- LCD Brightness
- Viewfinder Bright.
- GPS Settings (only with A55V)
- Power Save
- CTRL for HDMI
- Language
- Help Guide Display
- Upload Settings (appears only when an Eye-Fi card is installed)

- USB Connection
- Audio Signals
- Cleaning Mode
- Version
- Demo Mode
- Menu Start (with A35 only)
- Reset Default

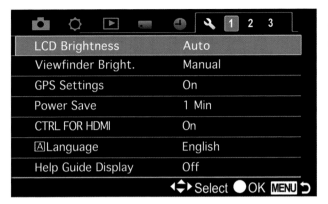

Figure 3.10
The Sony Alpha's
Setup 1 menu.

LCD Brightness

Options: Auto/Manual: Plus or minus 2, Sunny Weather (A55/A33); Manual, Sunny Weather (A35)

Default: Auto

When you access this menu choice, a pair of grayscale steps and a color chart appear on the screen, allowing you to see the effects of your brightness changes on the dark, light, and middle tones as well as colors. Select Auto to have the Alpha choose screen brightness for you. Choose Manual instead and a scale appears. Use the left/right controller buttons to adjust the brightness by plus or minus two (arbitrary) increments. If you find you have no trouble viewing the dimmed screen, you can set the brightness manually to 2 increments, and save some battery power. Finally, if you need to view the LCD while shooting outdoors in bright conditions, you can set this option to the Sunny Weather level for an extra boost of brightness, even brighter than the highest Manual setting. Be aware of the heavier drain on your battery if you take that route, though. If you find that it's too bright outdoors to use the LCD, I recommend that you use the viewfinder instead.

Viewfinder Bright.

Options: Auto/Manual: Plus or minus 1

Default: Auto

This menu item is similar to the LCD Brightness option discussed above. The difference is that, because the viewfinder is shaded from the sun or other bright lights, there is no need to enhance its brightness to a high level, as there is with the LCD. So, your only options here are to opt for the Auto setting or

to choose Manual and adjust the brightness by one unit in either direction. For the best view, you should look through the viewfinder when making adjustments.

GPS Settings (SLT-A55V Only)

Options: GPS On, Off; GPS Auto Time Cor. On, Off; Use GPS Assist Data; Delete GPS Ass. Data

Defaults: GPS On, GPS Auto Time Cor. On

The settings made through this menu item apply only to the SLT-A55V, which is equipped with a GPS receiver that allows it to include accurate location information with every image. You can use the setting on the first line of the submenu, GPS On/Off, to turn the GPS completely off and save some battery power if you're sure you won't need the location information for the images you're taking. Also, if you don't need to have the camera's time automatically corrected to match the GPS time data, you can turn off the Auto Time Correction option. With the third option on the GPS Settings submenu, you check to make sure the camera is using "GPS Assist Data," which you can download from the Internet using the Picture Motion Browser software and which can help the camera figure out its location more quickly. With the fourth and final option, you can delete the assist data when it has expired; it expires about 30 days after downloading.

Power Save

Options: 10 seconds, 20 seconds, 1 minute, 5 minutes, 30 minutes

Default: 1 minute

This setting determines the length of time before the Alpha switches to Power Save mode. Then, the display vanishes but can be restored by tapping the shutter release button or certain other controls, such as the MENU button. The choices are 10 or 20 seconds, or 1, 5, or 30 minutes. (If the camera is connected to a TV or the Drive mode is set to Remote Commander, the time period will be 30 minutes, no matter what setting is made here.)

CTRL for HDMI

Options: On, Off

Default: On

You can view the display output of your Alpha on a high-definition television (HDTV) if you make the investment in an HDMI cable with a mini-HDMI connector on the camera end (which Sony does not supply) and you own an

HDTV (which Sony does not supply with the camera, either). When connecting HDMI-to-HDMI, the camera automatically selects the correct image settings, including color broadcast system, for viewing. (Earlier Alpha models, which used a composite video connection instead of HDMI, had to be set to either NTSC or PAL broadcast standards.)

If you're lucky enough to own a TV that supports the Sony Bravia synchronization protocol, you can operate the camera using that TV's remote control. Just press the Link Menu button on the remote, and then use the device's controls to delete images, display an image index of photos in the camera, display a slide show, protect/unprotect images in the camera, specify printing options, and play back single images on the TV screen.

The CTRL for HDMI option on the Setup menu is intended for use when you have connected the camera to a non-Sony HDTV and find that the TV's remote control produces unintended results with the camera. If that happens, try turning this option off, and see if the problem is resolved.

Language

Options: English, French, Spanish, Italian, Japanese, Chinese languages

Default: Language of country where camera is sold

If you accidentally set a language you don't read and find yourself with incomprehensible menus, don't panic. Just choose the second option from the bottom of the Setup 1 menu, and select the idioma, lingua, or langue of your choice. Also, Sony has placed a symbol that looks like an alphabet block "A" at the beginning of this menu item, no matter which language is selected, so you can recognize this menu item even if it's in a language that you're not familiar with.

Help Guide Display

Options: On, Off

Default: On

The Alpha's Help Guide display provides quick snippets of information about various functions as you select them using the Fn button, direct-access buttons, or the mode dial, and then removes the information from the screen when you press the center controller button or shutter release. Once you've become comfortable with the operations of the camera, you may find that these factoids slow down your operation of the Alpha. You can turn them off with this menu option.

Upload Settings

Options: On, Off

Default: On

This menu item appears only when an Eye-Fi wireless (Wi-Fi) card is loaded into the camera. It enables/disables the upload function of the Eye-Fi card. The functions of the card itself are set, not in the camera, but using the Eye-Fi manager software supplied with the card. Follow the instructions that came with the Eye-Fi card to set up the access points, networks, and where/if uploaded pictures are to be forwarded to another location, such as Flickr or Facebook.

USB Connection

Options: Mass Storage, PTP

Default: Mass Storage

This first option on the Setup 2 menu (see Figure 3.11, which shows the A35 version; the A55/A33 lack the Menu Start entry) allows you to switch your USB connection protocol between the default Mass Storage setting (used when you transfer images from your camera to your computer), and PTP (Picture Transfer Protocol), which you'd use to connect your camera to a PictBridge-compatible printer. In Mass Storage mode, your camera appears to the computer as just another storage device, like a disk drive. You can drag and drop files between them. In PTP mode, the device you're connected to recognizes your camera as a camera and can communicate with it, which is what happens when you use a PictBridge printer.

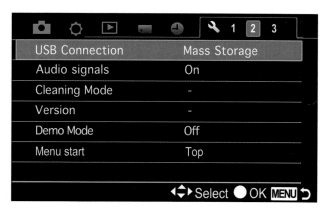

Figure 3.11
The Sony Alpha's Setup 2 menu.

Most of the time, you'll want to leave this setting at Mass Storage, changing it only when you're communicating with a PictBridge printer that requires a PTP connection.

Audio signals

Options: On, Off

Default: On

The Sony Alpha's internal beeper provides a helpful chirp to signify various functions, such as the focus lock and the countdown of your camera's self-timer. You can switch it off if you want to avoid the beeps because they are annoying, impolite, or distracting (at a concert or museum), or undesired for any other reason. (I've had new dSLR owners ask me how to turn off the "shutter sound" the camera makes; such an option was available in the point-and-shoot camera they'd used previously. You can't turn off all sounds made by an SLT camera like these Sony models, because, even though the mirror doesn't move, they still have moving shutters.) Select Audio Signals from the Setup 2 menu, choose On or Off, and press the center controller button.

Cleaning Mode

Options: Enter (perform cleaning), Cancel

Default: None

One of the Sony Alpha's best features is the automatic sensor cleaning system that reduces or eliminates the need to clean your camera's sensor manually using brushes, swabs, or bulb blowers. Sony has applied anti-static coatings to the image sensor and other portions of the camera body interior to counter charge build-ups that attract dust. The sensor vibrates ultrasonically each time the Alpha is powered off, shaking loose any dust, which is captured by a sticky strip beneath the sensor.

If you believe there is dust on the sensor and you want the camera to perform an automatic cleaning procedure, select this menu option. Make sure you have a fully charged battery or are using an optional AC adapter (Sony model number AC-PW20). Then, select this menu option and press Enter. You will hear a brief buzzing sound, during which the camera does its automatic vibration process to dislodge dust. The camera will then prompt you to turn off the power.

Version

Options: None

Select this menu option to display the version number of the firmware (internal operating software) installed in your camera. From time to time, Sony will update the original Version 1.00 firmware with a newer version that adds or enhances features or corrects operational bugs. In fact, the version in my camera is 1.10, which indicates that some changes have already been made to the original firmware. When a new version is released, it will be accompanied by instructions, which generally involve downloading the update to your computer, transferring it to a memory card, and then inserting that card into your camera using a specified procedure. In some cases, the update is done by connecting the camera by USB cable to a computer that has had the update file downloaded to it. It's a good idea to check occasionally at the Sony website, http://esupport.sony.com, to see if a new version of the camera's firmware is available for download. (You can also go to that site to download updates to the software that came with the camera, and to get general support information.)

Demo Mode

Options: On, Off

Default: Off

The only purpose of this menu option is to let you set the camera in a "demo mode," in which the camera will start to play a movie if it is left idle for about one minute. There is no built-in demo movie; you have to record your own movie for this function.

Menu Start

Options: Top, Previous

Default: Top

This menu option, available with the A35 only, lets you determine which menu position is used by default when you press the MENU button. If you select Top, then the first tab, the Shooting 1 menu, appears. Select Previous, and the last menu you accessed will be shown. I find the Previous option is the most convenient, because it's very likely that the last setting I made will be the one I want to access the next time (say, to turn off an option I wanted to use only temporarily), and the other menu tabs can be selected quickly even if most recently used choice is not the one I want next time.

Reset Default

Options: Enter, Cancel

Default: None

This entry is the last one on the Setup 2 menu of the A55/A33, and the first and only entry on the Setup 3 tab of the A35. If you've made a lot of changes to your Alpha's settings, you may want the camera to return to the factory settings so you can start over without manually going back through the menus and restoring everything. This menu selection lets you do that with the press of a few buttons. You can see the default values that will be reset at pages 156-158 of the Sony A55/A33 instruction manual; on pages 155-157 in the A35 manual.

Function Menu

It's time to drag out the Alpha's Fn (Function) menu again, mentioned in Chapters 1 and 2, but not explained in a great amount of detail in either. That's because several of the functions deserve complete descriptions within the context of their respective applications. For example, Autofocus mode, AF area, and metering mode are best deferred to the chapters that explain those features in exhaustive detail. This section will provide an overview that points you to the parts of the book that delve into the functions available from this menu.

The Function menu appears when you press the Fn button when the camera is in Shooting mode or in the main menu system (that is, when you're not reviewing an image on the LCD). (If the camera is in Playback or Auto Review mode, pressing the Fn button produces a screen that lets you rotate the image on display 90 degrees each time you press the center controller button.) If you have the Display Rec. Data option on the Custom 2 menu set to For Live View, the Fn menu will appear on the LCD superimposed over the Live View of the image. If the Display Rec. Data option is set to For Viewfinder, the Fn menu will appear on a dark background on the LCD. In either case, the Fn menu will appear in the viewfinder when the viewfinder is active, superimposed over the scene being viewed through the viewfinder.

This menu (see Figure 3.12) has up to 12 options, depending on the context. All 12 options are available when the Shooting mode is Program auto, Aperture priority, Shutter priority, or Manual. In other shooting modes, some of these items will not appear on the Function menu screen or will be grayed out and unavailable.

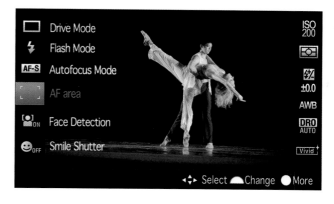

Figure 3.12
The Function
menu.

After you press the Fn button, the camera will show all of the available options on the LCD or viewfinder screen. Use the four controller buttons to scroll up and down and left and right among the various options. When the option you want is highlighted, you can press the center controller button to activate a submenu with the settings for that option. Or, if you want to take a quicker route, once the option is highlighted, just spin the control dial left or right to change the settings directly, without having to get into the submenu.

- **Drive mode.** This is the first option on the top left. There are several choices available through this single item on the screen: continuous shooting mode at high or low speed; self-timer; exposure bracketing; white balance bracketing; and Remote Commander.

- **Flash mode.** This entry calls forth a submenu that allows you to choose among the several flash modes that are available when the flash is popped up or an external flash is attached: Flash Off, AutoFlash, Fill flash, Slow Sync, Rear Curtain, and Wireless. Not all of these modes are available at all times. I'll describe the use of flash in detail in Chapter 4.

- **Autofocus mode.** This entry summons a terse submenu that allows you to choose *when* the Alpha locks in focus—AF-S (single autofocus), AF-C (continuous autofocus), or AF-A (automatic autofocus). These were described in Chapter 1.

- **AF area.** The Alpha includes 15 autofocus sensors arranged around the central portion of the viewfinder. You can elect to have the Alpha always choose which of the sensors to use, you can select any one of the 15 sensors yourself, or you can set the camera to always use the center autofocus point.

■ **Face Detection.** This option causes the camera to search for faces in the scene being photographed. If it detects a face, it adjusts the focus and exposure to produce the best possible image with one or more faces in sharp focus and properly exposed.

■ **Smile Shutter.** I mentioned this feature in Chapter 2. This function is related to Face Detection; when you turn Smile Shutter on, Face Detection is automatically turned on also. With Smile Shutter, the camera watches for a smile, and fires the shutter automatically each time it sees one. This is an interesting high-tech feature, because the subject's smile acts as a sort of remote control. Each time a person smiles, the camera clicks the shutter and takes a picture. There is no limit to the number of smiles and images; you, or whoever is in front of the camera, can keep smiling repeatedly, and the camera will keep taking more pictures, until it runs out of memory storage or battery power. Of course, the main purpose of this feature is not to act as a remote control; it's really intended to make sure your subject is smiling before the shutter fires. When you first activate Smile Shutter, you can use the right/left controller buttons to adjust the smile sensitivity for a slight, normal, or big smile.

■ **ISO sensitivity.** In addition to using the direct-access ISO button (the down controller button), you have the option of using the Fn menu to set the camera's ISO to Auto, or to various values from 100 to 12800. You also can choose Multi Frame Noise Reduction from this menu, in which case the ISO can be set as high as 25600.

■ **Metering mode.** The metering mode determines what part of the image is used to determine correct exposure. The Alpha can be set to evaluate multiple points within the image, concentrate only on the center portion of the frame, or measure a small spot in the middle of the shot.

■ **Flash compensation.** This feature works like exposure compensation, and allows you to dial in more or less exposure when using the flash. If your flash photo (such as a test shot) is too dark or too light, access this menu entry. Press the left/right controller buttons or spin the control dial to reduce or increase flash exposure by up to two steps; then press the center controller button to confirm your choice. This and other flash-related topics are discussed in detail in Chapter 4.

■ **White balance.** The different light sources you shoot under have differing color balances. Indoor light, for example, is much redder than outdoor illumination, which tends to have a bluish bias. The Alpha lets you choose the color/white balance that's appropriate, or it can make this adjustment automatically. You can choose Auto White Balance, and let the camera

select the proper setting, or you can select from several preset options for commonly encountered lighting situations: Daylight, Shade, Cloudy, Incandescent (standard light bulbs), Fluorescent, Flash, Color Temperature, and Custom. If you shoot in RAW quality, though, you don't have to worry about white balance at all, because you can easily adjust it in your software after the fact.

■ **D-Range Optimizer/Auto HDR.** The brightness/darkness range of many images is so broad that the sensor has difficulty capturing both the brightest highlight areas and the darkest shadow areas. The Alpha is able to expand its *dynamic range* using the D-Range Optimizer feature available from this menu entry. You can leave DRO turned off, set it to Auto, letting the camera decide how much processing to apply, or set it manually to any level of processing from 1 (weak) to 5 (strong).

In addition, this feature of the Alpha offers an Auto HDR setting. If you select Auto HDR, the camera takes three exposures at different exposure levels using an interval that you select, from 1.0 to 6.0 EV. It then combines the three exposures so as to lighten the shadows and darken the highlights of the resulting image, producing an enhanced dynamic range.

■ **Creative Style.** This option gives you six different combinations of contrast, saturation, and sharpness: Standard, Vivid, Portrait, Landscape, Sunset, and B/W (black-and-white). The Creative Style option is not available in the Auto or Scene modes, though it is available in all other shooting modes, including Sweep Panorama and Continuous Advance Priority AE.

Chapter 4

Using the Flash

Your Sony Alpha has a flip-up electronic flash unit built in, but you can also use an external flash (or, "strobe" or "speedlight"), either mounted on the Sony Alpha's accessory shoe or used off-camera and linked with a cable or triggered by a slave light (which sets off a flash when it senses the firing of another unit). This chapter deals primarily with using the camera's built-in flash; the options and permutations of working with one or more external flash units are so vast that squeezing more than an overview into a compact book would be impossible. You'll find the equivalent of more than 100 pages of coverage in my full-size books, *David Busch's Sony Alpha A55/A33 and A35 Guides to Digital SLR Photography.*

Consider using electronic flash:

- **When you need extra light.** Flash provides extra illumination in dark environments where existing light isn't enough for a good exposure, or is too uneven to allow a good exposure even with the camera mounted on a tripod.

- **When you don't need a precise preview of lighting effects.** Although some external units have a modeling flash feature that gives a preview of the strobe's effects, the "modeling" flash may not give you a precise look at what you're going to get. Unless you're using a studio flash with a full-time modeling lamp, electronic flash works best when you are able to visualize its effects in your mind, or don't need a precise preview.

- **When you need to stop action.** The brief duration of electronic flash serves as a very high "shutter speed" when the flash is the main or only source of illumination for the photo. Your Sony Alpha's shutter speed may be set for 1/160th second during a flash exposure, but if the flash illumination predominates, the *effective* exposure time will be the 1/1,000th to 1/50,000th second or less duration of the flash, because the flash unit reduces the amount of light released by cutting short the duration of the flash. However, if the ambient light is strong enough, it may produce a secondary, "ghost" exposure, as I'll explain later in this chapter.

■ **When you need flexibility.** Electronic flash's action-freezing power allows you to work without a tripod in the studio (and elsewhere), adding flexibility and speed when choosing angles and positions. External flash units can be easily filtered, and, because the filtration is placed over the light source rather than the lens, you don't need to use high-quality filter material.

■ **When you can use—or counter—flash's relatively shallow "depth-of-light" (the inverse square law).** Electronic flash units don't have the sun's advantage of being located 93 million miles from the subject, and suffer from the effects of their proximity. The *inverse square law* dictates that as a light source's distance increases from the subject, the amount of light reaching the subject falls off proportionately to the square of the distance. In plain English, that means that a flash or lamp that's eight feet away from a subject provides only one-quarter as much illumination as a source that's four feet away (rather than half as much). (See Figure 4.1.) You can *use* this effect to separate subjects located at different distances thanks to the differing amount of illumination each receives. But when you want a larger area blanketed more evenly with illumination, you have to *counter* the effects of the inverse square law, either with supplemental lighting, slow shutter speeds (which allow ambient light to register along with the flash), or by repositioning your subjects so all are within your flash's depth-of-light coverage.

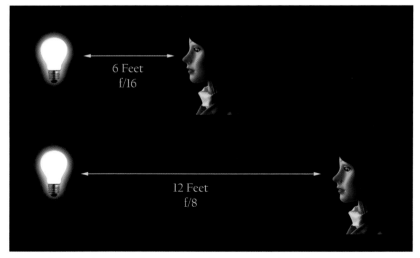

Figure 4.1 A light source that is twice as far away provides only one-quarter as much illumination.

Using the Built-In Flash

Your Alpha automatically pops up the built-in flash when there is insufficient light and you are using Auto, Portrait, Macro, and Night View/Night Scene modes. In PASM modes (Program, Aperture priority, Shutter priority, and Manual), you'll need to flip up the flash manually. In modes that do not pop up the flash, including Flash Off mode, the flash will not pop up. If the flash is already up, because you switched to a non-flash mode from a PASM, or if you have set Flash Off as the flash mode using the Fn button, the flash will not fire.

For example, the flash doesn't pop up in Landscape mode because the flash doesn't have enough reach to have much effect for pictures of distant vistas in any case; nor does the flash pop up automatically in Sports mode, because you'll often want to use shutter speeds faster than 1/160th second and/or be shooting subjects that are out of flash range. Pop-up flash is disabled in Flash Off mode for obvious reasons, but enabled, when appropriate, when you use Fill Flash mode.

If you happen to be shooting a landscape photo and do want to use flash (say, to add some illumination to a subject that's closer to the camera), or you want flash with your sports photos, or you *don't* want the flash popping up all the time when using one of the other Scene modes, switch to an appropriate PASM mode and use that instead. When trying to use flash in Scene modes that disable flash, a message appears on the LCD telling you the operation is invalid, with a suggestion to switch to Program, Aperture priority, Shutter priority, or Manual exposure modes.

When using a flash-compatible mode with the built-in flash, if you want the Alpha to issue a few additional low-light pre-flashes prior to taking the picture, turn the feature on with the Red Eye Reduc. option in Custom 1 menu, described in Chapter 3.

When using semi-automatic or manual exposure modes (or any Scene mode in which flash is used), if Red-eye reduction is turned on in the Custom menu, the red-eye reduction flash will emit as you press down the shutter release to take the picture, theoretically causing your subjects' irises to contract (if they are looking toward the camera), and thereby reducing the red-eye effect in your photograph.

Setting Flash Modes

To set the various flash modes (which may or may not be available, depending on which exposure mode you're using), press the Fn button on the back of the camera to the right of the LCD, navigate to the flash options using the controller buttons, and choose:

- **Flash Off.** The flash never fires; this may be useful in museums, concerts, or religious ceremonies where electronic flash would prove disruptive.
- **Auto Flash.** The flash fires as required, depending on lighting conditions.
- **Fill Flash.** The Alpha balances the available illumination with flash to provide a balanced lighting effect. See Figure 4.2 for an example.
- **Slow Sync.** The Alpha combines flash with slow shutter speeds, so that the subject can be illuminated by flash, but the longer shutter speed allows the ambient light to illuminate the background.
- **Rear Sync.** Fires the flash at the end of the exposure, producing more "realistic" "ghost" images, as described later in this chapter.
- **Wireless Flash.** The internal flash triggers compatible external flash units without the need for a connecting cord.
- **H (High-speed sync).** Available only when the HVF-F56AM or HVF-F43AM flash units are attached, it allows synchronizing those flashes at shutter speeds higher than 1/160th second.

Flash Exposure Compensation

It's important to keep in mind how the Alpha cameras' exposure compensation system works when you're using electronic flash. To activate exposure compensation for flash, press the Fn button and navigate to Flash Compens., then press the center controller button. The Flash comp. screen appears (see Figure 4.3), with its plus/minus scale. Use the left/right controller keys to add or subtract exposure. Pressing the right button adds exposure to an image; pressing the left button subtracts exposure. This function is not available when using Auto or Scene exposure modes, nor when you have used the Flash Off option from the Flash menu.

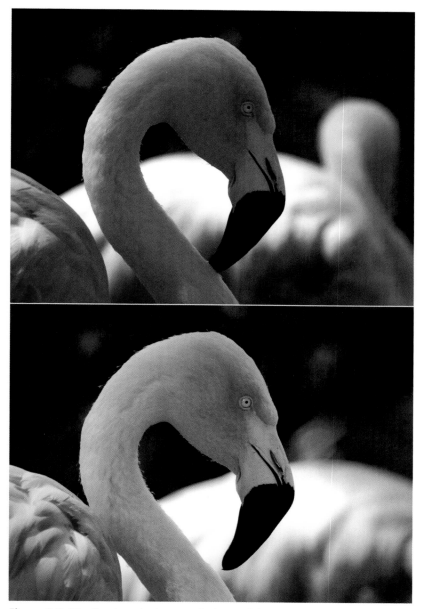

Figure 4.2 The flamingo (top) was in shadow. Fill flash (bottom) brightened up the bird, while adding a little catch light to its eye.

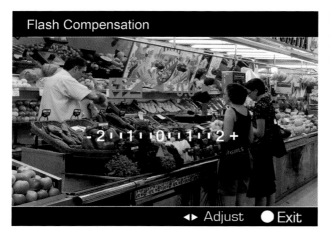

Figure 4.3
Adjust flash exposure using this screen.

Avoiding Sync Speed Problems

Using a shutter speed faster than the maximum sync speed can cause problems. Triggering the electronic flash only when the shutter is completely open makes a lot of sense if you think about what's going on. To obtain shutter speeds faster than 1/160th second, the Alpha exposes only part of the sensor at one time, by starting the second curtain on its journey before the first curtain has completely opened. That effectively provides a briefer exposure as the slit of the shutter passes over the surface of the sensor. If the flash were to fire during the time when the first and second curtains partially obscured the sensor, only the slit that was actually open would be exposed.

You'd end up with only a narrow band, representing the portion of the sensor that was exposed when the picture is taken. For shutter speeds *faster* than the top sync speed, the second curtain begins moving *before* the first curtain reaches the bottom of the frame. As a result, a moving slit, the distance between the first and second curtains, exposes one portion of the sensor at a time as it moves from the top to the bottom.

If the flash is triggered while this slit is moving, only the exposed portion of the sensor will receive any illumination. Note that the Alpha can use a feature called *high-speed sync* that allows shutter speeds faster than the maximum sync speed with certain external dedicated Sony flash units. When using high-speed sync, the flash fires a continuous serious of bursts at reduced power for the entire duration of the exposure, so that the illumination is able to expose the sensor as the slit moves.

HS sync is set using the controls that adjust the compatible external flash units, which include the HVL-F58AM, and HVL-F43AM. It cannot be used when working with multiple flash units. When active, the message H appears on the LCD panel on the back of the flash. You'll find complete instructions accompanying those flash units.

Ghost Images

The difference might not seem like much, but whether you use first-curtain sync (the default setting) or rear-curtain sync (an optional setting) can make a significant difference to your photograph *if the ambient light in your scene also contributes to the image.* At faster shutter speeds, particularly 1/160th second, there isn't much time for the ambient light to register, unless it is very bright. It's likely that the electronic flash will provide almost all the illumination, so first-curtain sync or second-curtain sync isn't very important.

However, at slower shutter speeds, or with very bright ambient light levels, there is a significant difference, particularly if your subject is moving, or the camera isn't steady. In any of those situations, the ambient light will register as a second image accompanying the flash exposure, and if there is movement (camera or subject), that additional image will not be in the same place as the flash exposure. It will show as a ghost image and, if the movement is significant enough, as a blurred ghost image trailing in front of or behind your subject in the direction of the movement.

As I mentioned earlier, when you're using first-curtain sync, the flash goes off the instant the shutter opens, producing an image of the subject on the sensor. Then, the shutter remains open for an additional period (which can be from 30 seconds to 1/160th second). If your subject is moving, say, towards the right side of the frame, the ghost image produced by the ambient light will produce a blur on the right side of the original subject image, making it look as if your sharp (flash-produced) image is chasing the ghost. For those of us who grew up with lightning-fast superheroes who always left a ghost trail *behind them*, that looks unnatural (see Figure 4.4).

So, Sony provides rear (second) curtain sync to remedy the situation. In that mode, the shutter opens, as before. The shutter remains open for its designated duration, and the ghost image forms. If your subject moves from the left side of the frame to the right side, the ghost will move from left to right, too. *Then*, about 1.5 milliseconds before the second shutter curtain closes, the flash is triggered, producing a nice, sharp flash image *ahead* of the ghost image. Voilà! We have monsieur *le Flash* outrunning his own trailing image.

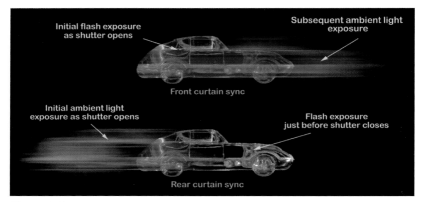

Figure 4.4 Front-curtain sync produces an image that trails in front of the flash exposure (top), whereas rear-curtain sync creates a more "natural looking" trail behind the flash image (bottom).

Slow Sync

Another flash synchronization option is *slow sync*, which is actually an exposure option that tells the A35 to use slower shutter speeds when possible, to allow you to capture a scene by both flash and ambient illumination. To activate Slow Sync, press the Fn button, navigate to the flash options, and choose Slow Sync.

Then, the exposure system will try to use longer shutter speeds with the flash, so that an initial exposure is made with the flash unit, and a secondary exposure of subjects in the background will be produced by the slower shutter speed. This will let you shoot a portrait of a person at night and, much of the time, avoid a dark background. Your portrait subject will be illuminated by the flash, and the background by the ambient light. It's a good idea to have the camera mounted on a tripod or some other support, or have SteadyShot switched on to avoid having this secondary exposure produce ghost images due to camera movement during the exposure.

Because Slow Sync is a type of exposure control, it does not work in Manual mode or Shutter priority mode (because the A35 doesn't choose the shutter speed in those modes).

Determining Exposure

Calculating the proper exposure for an electronic flash photograph is a bit more complicated than determining the settings by continuous light. The right exposure isn't simply a function of how far away your subject is, even though

the inverse square law I mentioned does have an effect: the farther away the subject is, the less light is available for the exposure. The Alpha can calculate distance if you're using a lens with "DT" in its name (these lenses transmit distance codes to the camera), based on the autofocus distance that's locked in just prior to taking the picture.

But, of course, flash exposure isn't based on distance alone. Various objects reflect more or less light at the same distance so, obviously, the camera needs to measure the amount of light reflected back and through the lens. Yet, as the flash itself isn't available for measuring until it's triggered, the Alpha has nothing to measure.

The solution is to fire the flash twice. The initial shot is a pre-flash that can be analyzed, then followed by a main flash that's given exactly the calculated intensity needed to provide a correct exposure. As a result, the primary flash may be longer for distant objects and shorter for closer subjects, depending on the required intensity for exposure. This through-the-lens evaluative flash exposure system when coupled with distance information from a DT lens is called *ADI flash exposure* (ADI stands for Advanced Distance Integration), and it operates whenever you have attached a Sony dedicated flash unit to the Alpha, and a lens that provides distance integration information. (Check the documentation that came with your lens to see if it is compatible with ADI.)

Using External Electronic Flash

Sony offers a broad range of accessory electronic flash units for the Alpha. They can be mounted to the flash accessory shoe, or used off-camera with a dedicated cord that plugs into the flash shoe to maintain full communications with the camera for all special features. (Non-dedicated flash units, such as studio flash, can be connected using a PC terminal adapter slipped into the flash shoe.)

Using the External Electronic Flash

Sony currently offers several accessory electronic flash units for the Sony Alpha cameras. They can be mounted to the flash accessory shoe, or used off-camera with a dedicated cord that plugs into the flash shoe to maintain full communications with the camera for all special features. The beefier units range from the HVL-F58AM, which can correctly expose subjects up to 17 feet away at f/11 and ISO 100, to the (discontinued) HVL-F36AM, which is good out to 11 feet at f/11 and ISO 100. (You'll get greater ranges at even higher ISO settings, of course.) A very inexpensive and useful unit, the $129 HVL-F20AM,

was introduced at the same time as this Alpha series. There is also an electronic flash unit, the HVL-RLAM Alpha Ring Light, specifically for specialized close-up flash photography.

HVL-F58AM Flash Unit

This $499 flagship of the Sony accessory flash line is the most powerful unit the company offers, with an ISO 100 guide number of 58/190 (meters/feet). Guide numbers are a standard way of specifying the power of a flash in manual, non-autoexposure mode. Divide the guide number by the distance to determine the correct f/stop. With a GN of 190, you would use f/19 at 10 feet (190 divided by 10), or f/8.5 at 20 feet.

This flash automatically adjusts for focal length settings from 24mm to 105mm, and a built-in slide-out diffuser panel boosts wide-angle coverage to 16mm. You can zoom coverage manually, if you like. There's also a slide-out "white card" that reflects some light forward even when bouncing the flash off the ceiling, to fill in shadows or add a catch light in the eyes of your portrait subjects.

Bouncing is particularly convenient and effective, thanks to what Sony calls a "quick shift bounce" system. This configuration is particularly effective when shooting vertical pictures. With most other on-camera external flash units, as soon as you turn the camera vertically, the flash is oriented vertically, too, whether you're using direct flash or bouncing off the ceiling (or, wall, when the camera is rotated). The HVL-58AM's clever pivoting system allows re-orienting the flash when the camera is in the vertical position, so flash coverage is still horizontal, and can be tilted up or down for ceiling bounce.

The 15.6 ounce unit uses convenient AA batteries in a four-pack, but can also be connected to the FA-EB1AM external battery adapter (you just blew another $250), which has room for 6 AA batteries for increased capacity and faster recycling. It automatically communicates white balance information to your camera, allowing the Alpha to adjust WB to match the flash output.

You can even simulate a modeling light effect. A test button on the back of the flash unit can be rotated for flash mode (one test flash, with no modeling light); three low-power flashes at a rate of two flashes per second, as a rough guide; and a more useful (but more power-consuming) mode that flashes for 40 flashes per second for 4 seconds (160 continuous mini-bursts in all). This switch also has a HOLD position that locks all flash operations except for the LCD data display on the flash, and the test button. Use this when you want to take a few pictures without flash, but don't want to turn off your flash or change its settings.

The HVL-F58AM can function as a main flash, or be triggered wirelessly by another compatible flash unit. The pre-flash from the second "main" flash is used to trigger the remote, wireless flash unit that has been removed or disconnected from the camera. When using flash wirelessly, Sony recommends rotating the unit so that the flashtube is pointed where you want the light to go, but the front (light sensor) of the flash is directed at the flash mounted on the camera. In wireless mode, you can control up to three groups of flashes, and specify the output levels for each group, giving you an easy way to control the lighting ratios of multiple flash units.

Those who are frustrated by an inability to use a shutter speed faster than 1/160th second will love the High Speed Sync (HSS) mode offered by this unit. When activated, you can take flash pictures at any shutter speed from 1/500th to 1/8,000th second! For example, if you want to use a high shutter speed and a very wide aperture to apply selective focus to a subject, HSS is one way to avoid overexposure when using flash. The mode button on the back of the flash is used to choose either TTL or Manual flash exposure. Once the flash mode is chosen, then use the Select button and flash plus/minus keys to activate HSS mode. HSS appears on the data panel of the flash, and an indicator appears on the camera's LCD monitor. (Note: HSS is not available when using the 2-second self-timer or rear-sync mode.)

Keep in mind that because less than the full duration of the flash is being used to expose each portion of the image as it is exposed by the slit passing in front of the sensor, the effective flash range of this "reduced" output is smaller. In addition, HSS cannot be used when using multiple flash or left/right/up bounce flash. (If you're pointing the flash downwards, say, at a close-up subject, HSS can be used.)

Another feature I like is the HVL-F58AM's multiple flash feature, which allows you to create interesting stroboscopic effects with several images of the same subject presented in the same frame. If you want to shoot subjects at distances of more than a few feet, however, you'll need to crank up the ISO setting of your Alpha, as the output of each strobe burst is significantly less than when using the flash for single shots.

HVL-F43AM Flash Unit

This less pricey (about $350) electronic flash replaces the older HVL-F42AM. It shares many of the advanced features of the HVL-F58AM, but has a lower guide number of 43/140 (meters/feet). (By now, you've figured out that the number in Sony's electronic flash units represent the GN in meters, so the power rating of the HVL-F36AM, described next, will not come as a surprise to you.)

The shared features include high-speed sync, automatic white balance adjustment, and automatic zoom with the same coverage from 24-105mm (16mm with the slide-out diffuser). This unit also can be used in wireless mode to operate other Sony strobes using a pre-flash signal. Bounce flash swiveling is still versatile, with adjustable angles of 90 degrees up, 90 degrees left, and 180 degrees right, so you can reflect your flash off ceilings, walls, or persons wearing large items of clothing in light colors. The HVL-F43AM is a tad lighter than its bigger sibling, at 12 ounces.

HVL-F36AM Flash Unit

Although discontinued, you can easily find this versatile flash available online or in used condition. The guide number for this lower cost ($199) Sony flash unit is (surprise!) 36/118 (meters/feet). Although (relatively) tiny at 9 ounces, you still get some big-flash features, such as wireless operation, auto zoom, and high-speed sync capabilities. Bounce flash flexibility is reduced a little, with no swiveling from side to side and only a vertical adjustment of up to 90 degrees available. Like its four siblings, this one uses four AA batteries.

HVL-F20AM Flash Unit

The least expensive Sony flash is this one, designed to appeal to the budget conscious, especially those who need just a bit of a boost for fill flash, or want a small unit (just 3.2 ounces) on their camera. It has a guide number of 20/65 at ISO 100, and features simplified operation. For example, there's a switch on the side of the unit providing Indoor and Outdoor settings (the Indoor setting tilts the flash upwards to provide bounce light; with the Outdoor setting, the flash fires directly at your subject). There are special modes for wide-angle shooting (use the built-in diffuser to spread the flash's coverage to that of a 27mm lens) or choose the Tele position to narrow the flash coverage to that of a 50mm lens for illuminating more distant subjects. While it's handy for fill flash, owners of a Sony Alpha may want a more powerful unit as their main electronic flash.

Chapter 5

Shooting Movies

The Alpha SLT cameras are unusually capable in the movie making arena, thanks to their ability to show you a real-time image through the viewfinder or on the LCD full time, with full autofocus capabilities while shooting video. So, even though you may have bought your Alpha primarily for shooting stationary scenes, you acquired a device that is equipped with a cutting-edge set of features for recording high-quality video clips. It can record high-definition (HD) video with stereo sound, and it is quite versatile in its feature set. Whether you're looking to record informal clips of the family on vacation, the latest viral video for YouTube, or a set of scenes that will be painstakingly crafted into a cinematic masterpiece using editing software, the Alpha SLT series will perform admirably.

When you set out to record video with the Alpha SLT, remember that, although a large memory card, such as a 16GB SDHC card, can hold about two hours of the highest-quality (AVCHD) video, the camera is limited in its ability to record continuous movie sequences. With the SteadyShot feature turned on, the A55/A35 can record for about 9 minutes. With SteadyShot turned off, either camera can record about 29 minutes of video continuously. The maximum movie file size is 2GB, though, and the camera will stop if that limit is reached while recording an MP4 file. If the camera is recording an AVCHD file, it will create a new file automatically when the 2GB limit is reached.

Preparing to Shoot Video

Before you start, you'll want to review the special movie settings first discussed in Chapter 3. To recap, these options are as follows:

- **Movie: File Format.** This item and the next two, below, are on the Recording 1 menu. Your options are AVCHD (the default), or MP4. Choose AVCHD for full high-definition video recording in the AVCHD format or the somewhat lesser quality MP4 format, which can be easier to

work with on a computer. If you select AVCHD there are no other choices to make, as AVCHD provides only one image size of 1920 × 1080 pixels.

■ **Movie: Size.** If you select MP4, you can choose between 1440 × 1080 (Standard HD, the default) and VGA (640 × 480). Use VGA if you need to save space on your memory card or don't need the higher quality.

■ **Movie: Audio Rec.** Select On (the default) or Off, depending on whether you want to record sound with your movie. You might want to disable sound if you are certain you don't want to have any sound recorded, plan to add sound later (say, narration), or if you believe you might be bothered by sounds from the operation of the camera or lens that might be recorded. It doesn't hurt to leave sound enabled, because you can easily erase a sound track in your movie editing software, and replace it with a new track. You never know when you might want some sounds recorded at the time of movie capture.

■ **Still/Movie Select.** This option, on the Playback 1 menu, lets you select playback of stills or video clips. Choose between Still (the default value) and Movie shooting. Your camera doesn't allow playing back stills and movies in a single sequence. You always must select one or the other, for normal playback or for Slide Show display. As described in Chapter 3, there are three ways to select between stills and movies for these purposes.

■ Use this menu option as described in Chapter 3, choosing either Still or Movie from the submenu.

■ Use the playback index screen, described in Chapter 1. On that screen, accessed by pushing the Zoom Out/Index button during playback mode, use the left direction button to navigate to the far left of the screen, then move up or down with the direction buttons to highlight either the icon for stills at the top of the screen or the icon for movies at the bottom.

■ Shift the camera into Still or Movie mode for playback by recording a quick still image or movie. In other words, if you want to display movies but don't want to go through either of the procedures outlined above, you can just press the red Movie button twice, which records a very short movie. This action shifts the camera into Movie mode for purposes of playback, so you can now press the Play button and you will be presented with the index of movies available to be played.

Recording a video with the Sony Alpha SLT series is extraordinarily easy to accomplish—just press the prominent red Movie button to the right of the viewfinder to start, and press it again to stop. Before you press that button,

though, there are some settings you should make to prepare the camera to record the scene the way you want it to. Setting up the camera for recording video can be a bit tricky, because it's not immediately obvious, either from the camera's menus or from Sony's user's guide, which settings apply to video recording and which do not. I will unravel that mystery for you, and throw in a few other tips to help improve your movies. First, here's what I recommend you do to prepare for your recording session:

- **Choose your resolution.** Go to the Recording 1 menu and select the format for your movies. You have two choices to make: File Format and Size. If you choose AVCHD for your file format, image size is automatically set at FH, for Full High Definition, a wide screen format whose size is 1920 × 1080 pixels. If you choose MP4 for the file format, you have two choices for image size: 1440 × 1080, which also is a wide screen HD format, or VGA, which is a lower quality format at a full-screen aspect ratio. Which format should you choose? It depends in part on your needs. If you want to save space on your memory card or computer and aren't too concerned about quality, you can choose VGA. If you want high quality and also want to edit your videos on a computer, I recommend the higher quality MP4 format (1440 × 1080). If you will be connecting the camera directly to an HDTV set, choose AVCHD; that format gives you the best quality, but its movies can be harder to manipulate and edit on a computer than videos in the MP4 formats.

- **Set the camera's aspect ratio.** The aspect ratio setting (3:2 or 16:9, accessed through the Image Size menu) won't affect your video recording, but it will affect how you frame your images using the Live View on the LCD screen. So, if you want to know approximately how your video will be framed on the screen, set the aspect ratio to 3:2 if you're going to be recording in VGA; set it to 16:9 if you'll be using any of the other formats. (For another way to get a visual preview of how a video will be framed with the current settings, turn on the Grid Line option in the Custom 2 menu, which will place a set of four small movie frame brackets on the screen; those brackets will show you the size of the movie frame before you press the red button to start recording.)

- **Turn on autofocus.** Make sure autofocus is turned on using the AF/MF switch on the lens or on the camera (assuming you're using a Sony lens that will autofocus with this camera). You have the option of using manual focus if you want, but in most cases there is no reason not to rely on the camera's excellent ability to autofocus during movie making. You also can set the Autofocus Area using the Function menu; if you set it to Local, you can move the active focus sensor while you're recording your video.

■ **Set white balance, Creative Style, and metering mode as you want them.** These are three exposure related functions that will work for your video shooting, so take advantage of them. Of course, for many purposes you may be content with Auto White Balance, the Standard Creative Style, and the Multi segment metering mode, but be aware that these settings are available if you want to use them for creative purposes. If you want to adjust any of these three settings, be sure to set the camera to a shooting mode, such as Program, in which those settings can be made; if you switch back to an Auto or Scene mode, the camera will revert back to its automatic settings. Make the settings before you start recording the movie, because you cannot adjust them during the recording. Don't worry about setting other exposure-related items, such as DRO, which will have no effect.

■ **Choose Aperture priority mode if you want to control the aperture.** In most cases, when you press the red Movie button, the camera will adjust the exposure for you automatically, no matter what shooting mode the camera is set to—Auto, Program, Manual, or even 3D Panorama or Continuous Advance Priority AE. The camera just records the movie, adjusting the aperture, shutter speed, and ISO to achieve a correct exposure. However, Sony provided the ability to maintain a fixed aperture if you want to. In order to do so, you need to use Aperture priority mode, and set your chosen aperture before starting to record the movie. If you then press the red Movie button, the camera will keep the aperture you have set, and do its best to expose the footage correctly using that aperture. The idea with this feature is to give you a way to achieve a defocused background by maintaining a wide aperture setting.

■ **Use the right card.** You'll want to use an SD Class 6 memory card or better to store your clips; slower cards may not keep pace with the volume of data being recorded. Choose a memory card with at least 4GB capacity (8GB or 16GB are even better).

■ **Attach an external microphone if desired.** One very welcome feature of the Alpha SLT series is the presence of a jack for an external stereo microphone, a refinement that is lacking on many modern cameras that are capable of recording movies. You can obtain a high-quality microphone made by a company such as Shure or Audio-Technica, and, if you are on a quest for really superior audio quality, you can even obtain a portable mixer that can plug into this jack, such as the affordable Rolls MX124, letting you use multiple high-quality microphones to record your soundtrack.

■ **Press the red Movie recording button.** You don't have to hold it down. Press it again when you're done.

MOVIE TIME

I've standardized on 16GB SDHC cards when I'm shooting movies; one of these cards will hold almost 2 hours of video at the highest AVCHD quality. However, the camera cannot shoot a continuous movie clip for more than 29 minutes, so that is your limit for any given scene; as noted earlier, it's even less when SteadyShot is turned on. (Though you could start right back in again to record a second scene, if you still had space on your memory card and still had battery power.)

GETTING INFO

The information display shown on the LCD screen when shooting movies is fairly sparse, because there are not too many settings you can make. The screen will show recording time elapsed and time remaining and the REC indicator to show that you are shooting a movie. It will also show you the format you are using and any exposure-related settings that are in effect, including white balance, Creative Style, and exposure compensation.

Steps During Movie Making

Once you have set up the camera for your video session and pressed the red button, you have done most of the technical work that's required of you. Now your task is to use your skills at composition, lighting, scene selection, and, perhaps, directing actors, to make a compelling video production. Later in this chapter I will have some advice to give you in those areas, but first there are a few technical points you should bear in mind as the camera is (figuratively) whirring away.

■ **Zoom, autofocus, and autoexposure all work.** If you're new to the world of high-quality still cameras that also take video, you may just take it for granted that functions such as autofocus continue to work normally when you switch from stills to video. But until recently, most such cameras performed weakly in their video modes; they would lock their exposure and focus at the beginning of the scene, and you could not zoom while shooting the video. The Alpha SLT series has no such handicaps, and, in fact, it is especially capable in these areas. Autoexposure works very well, and you can zoom to your heart's content (though, as I'll discuss later, I recommend that you zoom sparingly). Best of all, autofocus works like a charm; the camera can track moving subjects and quickly snap them back into sharp focus with the speedy Phase Detection focusing

mechanism made possible by the fixed translucent mirror. So don't limit yourself based on the weaknesses of past cameras; these SLT models open up new horizons of video freedom. Also, as I mentioned above, if the AF Area is set to Local, you have the ability to change to a different focus sensor while recording the movie.

■ **Exposure compensation works while filming.** I found this feature to be quite remarkable. Although the autoexposure system works very well to vary the aperture when the ambient lighting changes, you also have the option of dialing in exposure compensation if you see a need for more or less brightness in a particular context. You could even use this function as a limited kind of "fade to black" in the camera, though you probably won't be able to fade quite all the way to black. Again, you may never need to adjust your EV manually while shooting video, but it's great to know that you have the option available.

■ **Don't be a Flash in the pan.** With HD video, there is a possibility of introducing artifacts or distortion if you pan too quickly. That is, because of the way the lines of video are displayed in sequence, if the camera moves too quickly in a sideways motion, some of the lines may not show up on the screen quickly enough to catch up to the rest of the picture, resulting in a somewhat distorted effect and/or loss of detail. So, if at all possible, make your pans smooth and steady, and slow them down to a comfortable pace.

Tips for Shooting Better Movies

Producing high-quality movies can be a real challenge for amateur photographers. After all, by comparison we're used to watching the best productions that television, video, and motion pictures can offer. Whether it's fair or not, our efforts are compared to what we're used to seeing produced by experts. While this chapter can't make you into a pro videographer, it can help you improve your efforts.

There are a number of different things to consider when planning a video shoot, and when possible, a shooting script and storyboard can help you produce a higher quality video.

Make a Shooting Script

A shooting script is nothing more than a coordinated plan that covers both audio and video and provides order and structure for your video. A detailed script will cover what types of shots you're going after, what dialogue you're going to use, audio effects, transitions, and graphics. When you first begin

shooting movies, your shooting scripts will be very simple. As you gain experience, you'll learn how to tell stories with video, and will map out your script in more detail before you even begin to capture the first sequence.

A shooting script will also help you if you need to shoot out of sequence. For example, you may have several scenes that take place on different days at the same location. It probably will make sense to shoot all those scenes at one time, rather than in the movie's chronological order. You can check the shooting script to see what types of video and audio you need for the separate scenes, as well as what dialogue your "actors" need to deliver (even, if, as is the case for most informal videos, the "lines" are ad-libbed as you shoot).

Use Storyboards

A storyboard is a series of panels providing visuals of what each scene should look like. While the ones produced by Hollywood are generally of very high quality, there's nothing that says drawing skills are important for this step. Stick figures work just fine if that's the best you can do. The storyboard just helps you visualize locations, placement of actors/actresses, props and furniture, and also helps everyone involved get an idea of what you're trying to show. It also helps show how you want to frame or compose a shot. You can even shoot a series of still photos and transform them into a "storyboard" if you want, as I did in Figure 5.1. In this case, I took pictures of a parade, and then used them to assemble a storyboard to follow when I shot video at a similar parade on a later date.

Storytelling in Video

Today's audience is accustomed to fast-paced, short scene storytelling. In order to produce interesting video for such viewers, it's important to view video storytelling as a kind of shorthand code for the more leisurely efforts print media

Figure 5.1 A storyboard is a series of simple photographs or sketches to help visualize a segment of video.

offers. Audio and video should always be advancing the story. While it's okay to let the camera linger from time to time, it should only be for a compelling reason and only briefly.

Composition is one of the most important tools available to you for telling a story in video. However, while you can crop a still frame any old way you like, in movie shooting, several factors restrict your composition, and impose requirements you just don't always have in still photography (although other rules of good composition do apply). Here are some of the key differences to keep in mind when composing movie frames:

- **Horizontal compositions only.** Some subjects, such as basketball players and tall buildings, just lend themselves to vertical compositions. But movies are shown in horizontal format only. So if you're interviewing a local basketball star, you can end up with a worst-case situation like the one shown in Figure 5.2. Using the A55/A35/A33's FH (1920 × 1080) format in AVCHD mode, or 1080 (1440 × 1080) format in MP4 mode, you are limited to relatively wide frames. If you want to show how tall your subject is, it's often impractical to move back far enough to show him full-length. You really can't capture a vertical composition. Tricks like getting down on the floor and shooting up at your subject can exaggerate the perspective, but aren't a perfect solution.

- **Wasted space at the sides.** Moving in to frame the basketball player as outlined by the yellow box in Figure 5.2, means that you're still forced to leave a lot of empty space on either side. (Of course, you can fill that space with other people and/or interesting stuff, but that defeats your intent of concentrating on your main subject.) So when faced with some types of subjects in a horizontal frame, you can be creative, or move in *really* tight. For example, if I was willing to give up the "height" aspect of my composition, I could have framed the shot as shown by the green box in the figure, and wasted less of the image area at either side of the cage star. The least attractive option is to switch to a movie recording format that has less "wide-screen" perspective, specifically 640 × 480 pixels in MP4 mode, in which case you lose the resolution advantage of the HD aspect ratio.

- **Seamless (or seamed) transitions.** Unless you're telling a picture story with a photo essay, still pictures often stand alone. But with movies, each of your compositions must relate to the shot that preceded it, and the one that follows. It can be jarring to jump from a long shot to a tight close-up unless the director—you—is very creative. Another common error is the "jump cut" in which successive shots vary only slightly in camera angle, making it appear that the main subject has "jumped" from one place to another. (Although everyone from French New Wave director Jean-Luc Goddard to Guy Ritchie—Madonna's ex—have used jump cuts

effectively in their films.) The rule of thumb is to vary the camera angle by at least 30 degrees between shots to make it appear to be seamless. Unless you prefer that your images flaunt convention and appear to be "seamy."

■ **The time dimension.** Unlike still photography, with motion pictures there's a lot more emphasis on using a series of images to build on each other to tell a story. Static shots where the camera is mounted on a tripod and everything is shot from the same distance are a recipe for dull videos. Watch a television program sometime and notice how often camera shots change distances and directions. Viewers are used to this variety and have come to expect it. Professional video productions are often done with multiple cameras shooting from different angles and positions. But many professional productions though are shot with just one camera and careful planning, and you can do just fine with your camera.

Figure 5.2 Movie shooting requires you to fit all your subjects into a horizontally oriented frame.

Within those compositional restraints, you still have a great deal of flexibility. It only takes a second or two for an establishing shot to impart the necessary information. For example, many of the scenes for a video documenting a model being photographed in a Rock and Roll music setting might be close-ups and talking heads, but an establishing shot showing the studio where the video was captured helps set the scene.

Provide variety too. Change camera angles and perspectives often and never leave a static scene on the screen for a long period of time. (You can record a static scene for a reasonably long period and then edit in other shots that cut away and back to the longer scene with close-ups that show each person talking.)

When editing, keep transitions basic! I can't stress this one enough. Watch a television program or movie. The action "jumps" from one scene or person to the next. Fancy transitions that involve exotic "wipes," dissolves, or cross fades take too long for the average viewer and make your video ponderous. Movie shooting calls for careful composition, and, in the case of HD video format, that composition must be framed by the 16:9 aspect ratio of the format. Static shots where the camera is mounted on a tripod and everything's shot from the same distance are a recipe for dull videos. Try these tricks:

- **Establishing shot.** This composition, shown at left in Figure 5.3, establishes the scene and tells the viewer where the action is taking place.

- **Medium shot.** This shot is composed from about waist to headroom (some space above the subject's head). It's useful for providing variety from a series of close-ups and also makes for a useful first look at a speaker. (See Figure 5.3, right.)

- **Close-up.** The close-up, usually described as "from shirt pocket to head room," provides a good composition for someone talking directly to the camera. (See Figure 5.4, left.)

- **Extreme close-up.** This shot has been described as the "big talking face" shot. Styles and tastes change over the years and now the big talking face is much more commonly used (maybe people are better looking these days?) and so this view may be appropriate. (See Figure 5.4, right.)

- **"Two" shot.** A two shot shows a pair of subjects in one frame. They can be side by side or one in the foreground and one in the background. Subjects can be standing or seated. (See Figure 5.5, left.) A "three shot" is the same principle except that three people are in the frame.

- **Over the shoulder shot.** Long a tool of interview programs, the "over the shoulder shot" uses the rear of one person's head and shoulder to serve as a frame for the other person. This puts the viewer's perspective as that of the person facing away from the camera. (See Figure 5.5, right.)

Figure 5.3

Figure 5.4

Figure 5.5

Lighting for Video

Much like in still photography, how you handle light pretty much can make or break your videography. Lighting for video though can be more complicated than lighting for still photography, since both subject and camera movement is often part of the process.

Lighting for video presents several concerns. First off, you want enough illumination to create a useable video. Beyond that, you want to use light to help tell your story or increase drama. Let's take a better look at both.

Illumination

You can significantly improve the quality of your video by increasing the light falling in the scene. This is true indoors or out, by the way. While it may seem like sunlight is more than enough, it depends on how much contrast you're dealing with. If your subject is in shadow (which can help them from squinting) or wearing a ball cap, a video light can help make him look a lot better.

Lighting choices for amateur videographers are a lot better these days than they were a decade or two ago. An inexpensive shoe mount video light, which will easily fit in a camera bag, can be found for $15 or $20. You can even get a good quality LED video light for less than $100. Work lights sold at many home improvement stores can also serve as video lights since you can set the camera's white balance to correct for any colorcasts.

Much of the challenge depends upon whether you're just trying to add some fill light on your subject versus trying to boost the light on an entire scene. A small video light in the camera's hot shoe mount or on a flash bracket will do just fine for the former. It won't handle the latter.

Creative Lighting

While ramping up the light intensity will produce better technical quality in your video, it won't necessarily improve the artistic quality of it. Whether we're outdoors or indoors, we're used to seeing light come from above. Videographers need to consider how they position their lights to provide even illumination while up high enough to angle shadows down low and out of sight of the camera.

When considering lighting for video, there are several factors. One is the quality of the light. It can either be hard (direct) light or soft (diffused). Hard light is good for showing detail, but can also be very harsh and unforgiving. "Softening" the light, but diffusing it somehow, can reduce the intensity of the light but make for a kinder, gentler light as well.

While mixing light sources isn't always a good idea, one approach is to combine window light with supplemental lighting. Position your subject with the window to one side and bring in either a supplemental light or a reflector to the other side for reasonably even lighting.

Lighting Styles

Some lighting styles are more heavily used than others. Some forms are used for special effects, while others are designed to be invisible. At its most basic, lighting just illuminates the scene, but when used properly it can also create drama.

Let's look at some types of lighting styles:

- **Three-point lighting.** This is a basic lighting setup for one person. A main light illuminates the strong side of a person's face, while a fill light lights up the other side. A third light is then positioned above and behind the subject to light the back of the head and shoulders.

- **Flat lighting.** Use this type of lighting to provide illumination and nothing more. It calls for a variety of lights and diffusers set to raise the light level in a space enough for good video reproduction, but not to create a particular mood or emphasize a particular scene or individual. With flat lighting, you're trying to create even lighting levels throughout the video space and minimizing any shadows. Generally the lights are placed up high and angled downward (or possibly pointed straight up to bounce off of a white ceiling).

- **"Ghoul lighting."** This is the style of lighting used for old horror movies. The idea is to position the light down low, pointed upwards. It's such an unnatural style of lighting that it makes its targets seem weird and ghoulish.

- **Outdoor lighting.** While shooting outdoors may seem easier because the sun provides more light, it also presents its own problems. As a general rule of thumb, keep the sun behind you when you're shooting video outdoors, except when shooting faces (anything from a medium shot and closer) since the viewer won't want to see a squinting subject. When shooting another human this way, put the sun behind him and use a video light to balance light levels between the foreground and background. If the sun is simply too bright, position the subject in the shade and use the video light for your main illumination. Using reflectors (white board panels or aluminum foil covered cardboard panels are cheap options) can also help balance light effectively.

- **On-camera lighting.** While not "technically" a lighting style, this method is commonly used. A hot shoe mounted light provides direct lighting in the same direction the lens is pointing. It's commonly used at weddings, events, and in photojournalism since it's easy and portable. LED video lights are all the rage these days and a wide variety of these lights are available at various price points. At the low end, these lights tend to be small and produce minimal light (but useful for fill work). More expensive versions offer greater light output and come with built-in barn doors (panels that help you control and shape the light) and diffusers and filters.

Audio

When it comes to making a successful video, audio quality is one of those things that separates the professionals from the amateurs. We're used to watching top-quality productions on television and in the movies, yet the average person has no idea of how much effort goes in to producing what seems to be "natural" sound. Much of the sound you hear in such productions is actually recorded on carefully controlled sound stages and "sweetened" with a variety of sound effects and other recordings of "natural" sound.

Tips for Better Audio

Since recording high-quality audio is such a challenge, it's a good idea to do everything possible to maximize recording quality. Here are some ideas for improving the quality of the audio your camera records:

■ **Use an external microphone.** You'll recall the description of the SLT cameras' external microphone port in Chapter 2. As noted, this port accepts a stereo mini-plug from a standard external microphone, allowing you to achieve considerably higher audio quality for your movies than is possible with the camera's built-in microphones (which are disabled when an external mic is plugged in). An external microphone reduces the amount of camera-induced noise that is picked up and recorded on your audio track. (The action of the lens as it focuses can be audible when the built-in microphones are active.)

The external microphone port can provide plug-in power for microphones that can take their power from this sort of outlet rather than from a battery in the microphone. Sony provides optional compatible microphones such as the ECM-ALST1 and the ECM-CG50; you also may find suitable microphones from companies such as Shure and Audio-Technica.

■ **Get the camera and microphone close to the speaker.** The farther the microphone is from the audio source, the less effective it will be in picking up that sound. While having to position the camera and microphone closer to the subject affects your lens choices and lens perspective options, it will make the most of your audio source. Of course, if you're using a very wide-angle lens, getting too close to your subject can have unflattering results, so don't take this advice too far.

■ **Turn off any sound makers you can.** Little things like fans and air handling units aren't obvious to the human ear, but will be picked up by the microphone. Turn off any machinery or devices that you can plus make sure cell phones are set to silent mode. Also, do what you can to minimize sounds such as wind, radio, television, or people talking in the background.

■ **Make sure to record some "natural" sound.** If you're shooting video at an event of some kind, make sure you get some background sound that you can add to your audio as desired in postproduction.

■ **Consider recording audio separately.** Lip-syncing is probably beyond most of the people you're going to be shooting, but there's nothing that says you can't record narration separately and add it later. It's relatively easy if you learn how to use simple software video-editing programs like iMovie (for the Macintosh) or Windows Movie Maker (for Windows PCs). Any time the speaker is off-camera, you can work with separately recorded narration rather than recording the speaker on-camera. This can produce much cleaner sound.

Chapter 6

Shooting Tips

Here you'll find tips on settings to use for different kinds of shooting, beginning with recommended settings for some menu options. You can set up your camera to shoot the main type of scenes you work with, then use the charts that follow to make changes for other kinds of images. Most will set up their SLT camera for my All Purpose settings, and adjust from there.

Default, All Purpose, Sports—Outdoors, Sports—Indoors

	Default	All Purpose	Sports Outdoors	Sports Indoors
Exposure mode	Your choice	P	S	S
Autofocus mode	AF-A	AF-A	AF-C	AF-C
AF area	Wide	Wide	Local	Spot
Face Detection	On	On	Off	Off
Drive mode	Single Shot Advance	Single Shot Advance	Continuous High	Continuous High
Recording menus				
AF illuminator	Auto	Auto	Disabled	Disabled
Color space	sRGB	sRGB	sRGB	sRGB
Long exposure NR	On	On	Off	Off
High ISO NR	Auto	Auto	Weak (automatically set)	Weak (automatically set)
Custom menus				
Grid Line	Off	Off	Off	Off
Auto review	Off	Off	Off	Off
Playback menus				
Volume setting	2	2	0	0
Playback display	Auto rotate, manual rotate	Auto rotate	Manual rotate	Manual rotate
Setup menus				
LCD brightness		Auto	Sunny weather	Auto
Help Guide Display	On	On	Off	Off
Audio signals	On	On	Off	Off

Stage, Long Exposure, HDR-Manual, Portrait

	Stage	Long Exposure	HDR - Manual	Portrait
Exposure mode	S	M	A	A
Autofocus mode	AF-C	Manual	Manual	AF-S
AF area	Spot	N/A	N/A	Spot
Face Detection	On	Off	Off	Off
Drive mode	Single Shot Advance	Single Shot Advance	Continuous High	Continuous Low
Recording menus				
AF illuminator	Auto	Auto	Disabled	Disabled
Color space	sRGB	Adobe RGB	Adobe RGB	Adobe RGB
Long exposure NR	On	On	Off	Off
High ISO NR	Auto	Auto	Weak (automatically set)	Weak (automatically set)
Custom menus				
Grid Line	Off	Off	Off	Off
Auto review	Off	Off	Off	2 seconds
Playback menus				
Volume setting	2	2	0	0
Playback display	Auto rotate	Auto rotate	Manual rotate	Manual rotate
Setup menus				
LCD brightness	Auto	Auto	Sunny weather	Auto
Help Guide Display	Off	Off	Off	Off
Audio signals	Off	On	On	Off

Studio Flash, Landscape, Macro, Travel

	Studio Flash	Landscape	Macro	Travel/Architecture
Exposure mode	Manual	P	A	S
Autofocus mode	AF-A	AF-S	AF-A or Manual	AF-A
AF area	Wide	Wide	Spot	Local
Face Detection	Off	Off	Off	On
Drive mode	Single Shot Advance	Single Shot Advance	Single Shot Advance	Single Shot Advance
Recording menus				
AF illuminator	Auto	Auto	Auto	Auto
Color space	Adobe RGB	sRGB	sRGB	sRGB
Long exposure NR	Off	Off	Off	Off
High ISO NR	Auto	Auto	Weak	Weak
Custom menus				
Grid Line	Off	Rule of Thirds	Rule of Thirds	Rule of Thirds for Architecture
Auto review	Off	10 seconds	Off	2 seconds
Playback menus				
Volume setting	2	2	0	0
Playback display	Auto rotate	Auto rotate	Manual rotate	Manual rotate
Setup menus				
LCD brightness	Auto	Auto	Sunny weather	Auto
Help Guide Display	Off	Off	Off	On
Audio signals	Off	On	Off	Off

Index